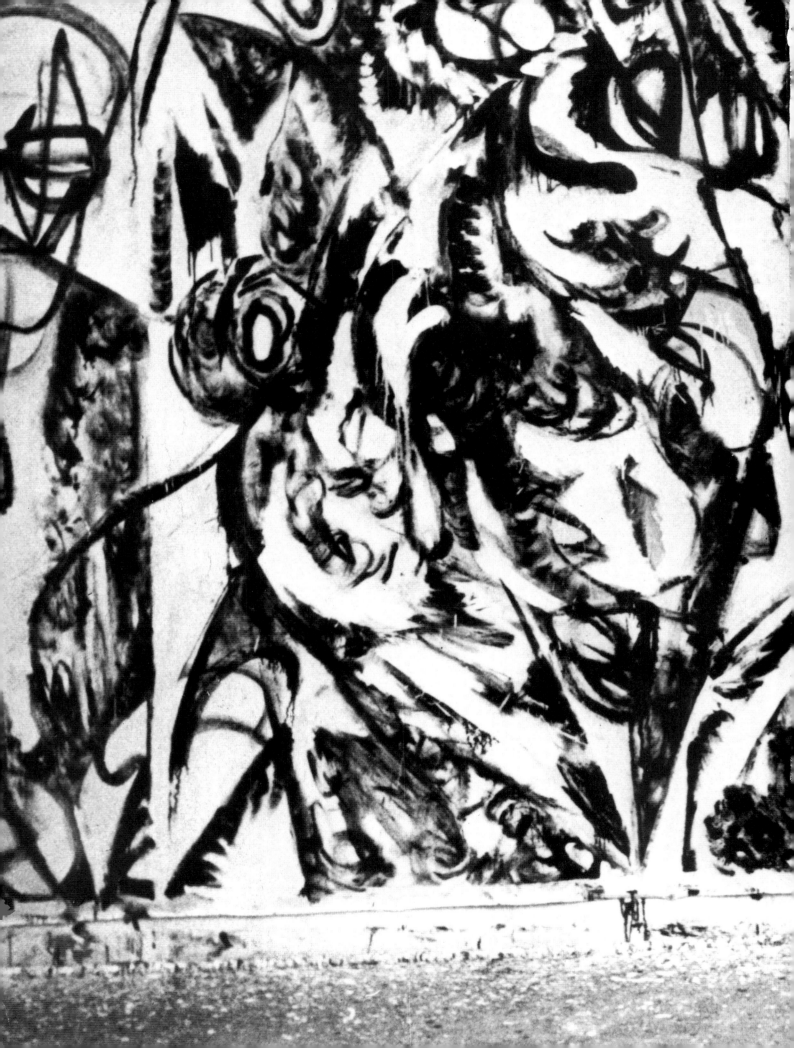

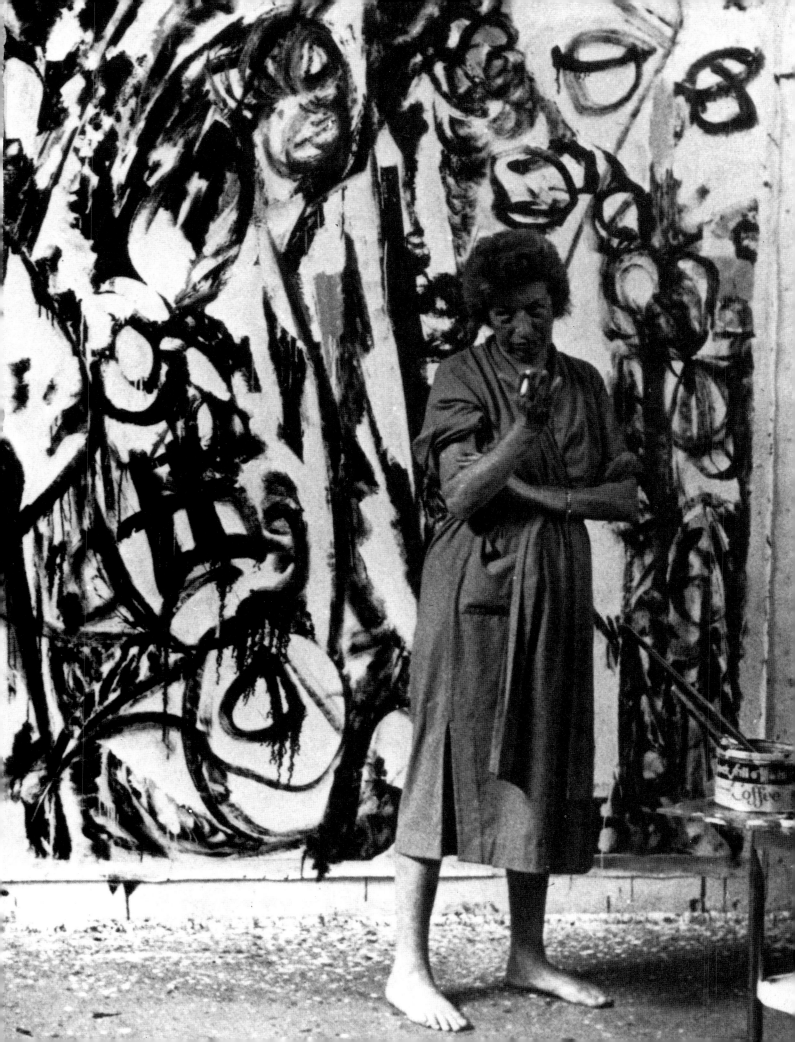

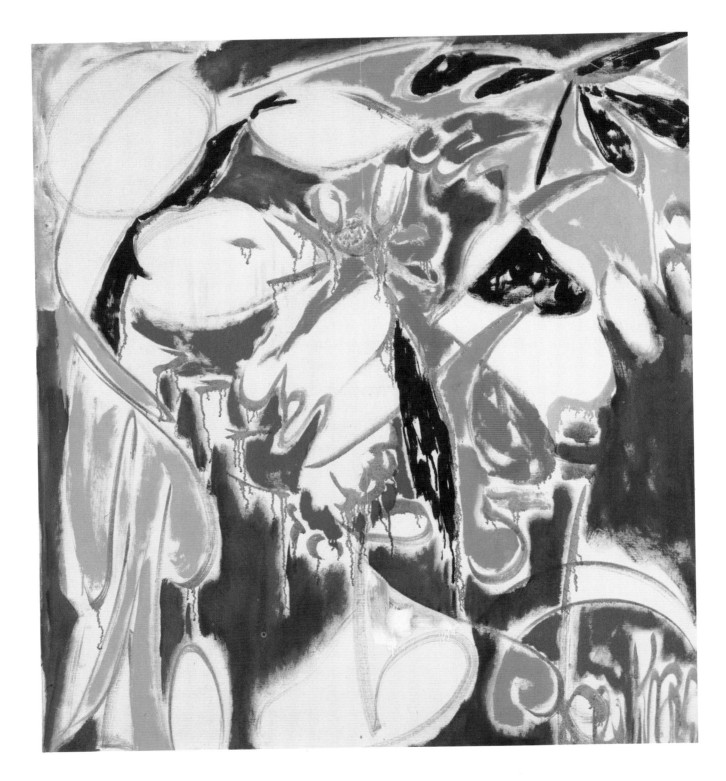

MODERN MASTERS

LEE KRASNER

ROBERT HOBBS

Abbeville Press Publishers
New York London Paris

Lee Krasner is volume fifteen in the Modern Masters series.

ACKNOWLEDGMENTS: In the course of organizing the exhibition *Abstract Expressionism: The Formative Years,* Gail Levin and I spent three days in The Springs interviewing Lee Krasner. Our discussions were so revealing that Krasner persuaded Barbara Rose to bring a film crew to record our last interview. The memory of these discussions was a major factor in my taking on this monograph. Lee Krasner was formidable, witty, painfully honest, and wonderfully human. Although this book focuses on her art, I hope it suggests some of the power and presence of her character as well.

This project has been supported in a number of ways. Helen A. Harrison and Chris McNamarra of the Pollock-Krasner House have been both helpful and hospitable. Florida State University awarded me a summer faculty research grant, and Virginia Commonwealth University appointed me to the Rhoda Thalhimer Endowed Chair in American Art History, a position that has provided the time needed to complete this project. At VCU I have particularly appreciated conversations with Dr. Fredricka Jacobs, the encouragement of Dr. Murray De Pillars and Bruce Koplin, and the secretarial expertise of Ariana Bracalente, Phyllis J. Green, and Betsy Patterson. Mary Lynch has served the project well as a dedicated research assistant. I have had the great fortune to work with the highly capable staff at the Robert Miller Gallery, New York, including Diana Bulman, John Cheim, Nathan Kernan, and Robert Miller. At Abbeville, Nancy Grubb has been a superb editor. My discussions with the American Foundations Faculty and Class of 1992 have also proven enlightening. Karen Bussolini, Mark Lindquist, Lillian Kiesler, and John Scofield have supported this project in numerous ways, as have family members who have understood how much time such an undertaking entails.

FRONT COVER: *Bird Talk,* 1955. See plate 53.
BACK COVER: *Rising Green,* 1972. See plate 79.
FRONT ENDPAPERS: Lee Krasner in her studio, n.d.
Photograph by Halley Erskine.
BACK ENDPAPERS: Lee Krasner in her studio, 1983. Photograph by Hans Namuth.
FRONTISPIECE: *Listen,* 1957. Oil on canvas, 63½ x 58⅜ in. (161.3 x 148.3 cm).
Anna Marie and Robert F. Shapiro; Courtesy Robert Miller Gallery, New York.

Series design by Howard Morris
Editor: Nancy Grubb
Designer: Laura Lindgren
Production Editor: Alice Gray
Picture Editor: Margot Clark-Junkins
Production Supervisor: Simone Rene
Chronology, Exhibitions, Public Collections, and Selected Bibliography compiled by Robert Hobbs

Marginal numbers in the text refer to works illustrated in this volume.

Library of Congress Cataloging-in-Publication Data

Hobbs, Robert Carleton, 1946–
 Modern Masters : Lee Krasner / Robert Hobbs.
 p. cm.
 Includes bibliographical references and index.
 ISBN 1-55859-651-8 (cloth) ISBN 1-55859-283-0 (paper)
1. Krasner, Lee, 1908–1984. —Criticism and interpretation.
2. Abstract expressionism—United States. 1. Krasner, Lee, 1908–1984.
II. Title.
ND237.K677H63 1993 93-4141
759.13—dc20

First edition

Contents

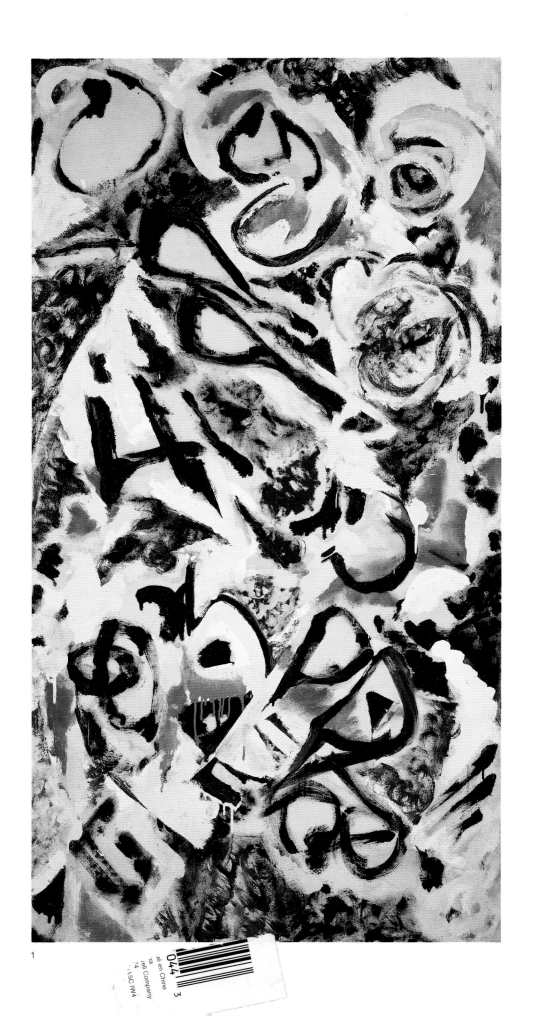

té en Chine
ia
ell Company
74
L5C IW4

Introduction

Lee Krasner occupies a special place in the history of Abstract Expressionism. The only major female in a group of artists known for their misogyny, she offers a welcome antidote to their macho-oriented individuality. Much of her work provides a feminist critique of Abstract Expressionism in particular and the male ego in general. Whereas many of the Abstract Expressionists suffered bitterly in the course of their individual quests—several were diagnosed alcoholics and at least two committed suicide—Krasner tended to thrive on adversity. Rather than viewing herself and her art as autonomous, she approached her work as a profoundly important forum for dealing with ideas about the self, nature, and modern life.[1]

Krasner's friend John Graham once wrote, "Starting a painting is starting an argument in terms of canvas and paint."[2] Taking Graham a step further, she turned the process of painting into an intense debate with herself and with other artists. She took her aesthetic cues from the male Abstract Expressionists, but in many cases she used her work to counter their artistic assertions. Her many statements about her life with Jackson Pollock and her indebtedness to his style indicate that Krasner never admitted, even to herself, that she had challenged and eventually abandoned him. Her sense of honor demanded that she play the role of devoted wife and faithful disciple, but what she could not admit verbally she expressed in her art. Her work vividly chronicles her initial reassessment of Pollock's art and her later critique of aspects of Abstract Expressionism in general. Beginning with her last group of Little Images and continuing, more radically, in her first black-and-white collages, Krasner evaluated Pollock's late work and found it lacking in intellectual rigor. She continued this critique when she cut up Pollock's abandoned paint-spattered canvases and used them in several collages. Although this act might be viewed as a commendable reclamation, it was also an act of aggression, given Pollock's inactivity and deeply depressed state. For Krasner this mode of working was productive since it enabled her to acknowledge and redirect the self-destructive forces in her own nature.

1. *Spring Memory*, 1959
Oil on canvas, 70 x 37½ in. (177.8 x 95.2 cm)
Robert Miller Gallery, New York

PAGES 8–9

2. *Sun Woman I*, 1957
Oil on canvas, 97¼ x 70¼ in. (247 x 178.4 cm)
Private collection; Courtesy Jason McCoy, Inc., New York

3. *Sun Woman II*, 1957
Oil on canvas, 69½ x 113½ in. (176.5 x 288.3 cm)
The Estate of Lee Krasner; Courtesy Robert Miller Gallery, New York

4. *Palingenesis*, 1971
Oil on canvas, 82 x 134 in. (208.3 x 340.4 cm)
The Estate of Lee Krasner; Courtesy Robert Miller Gallery, New York

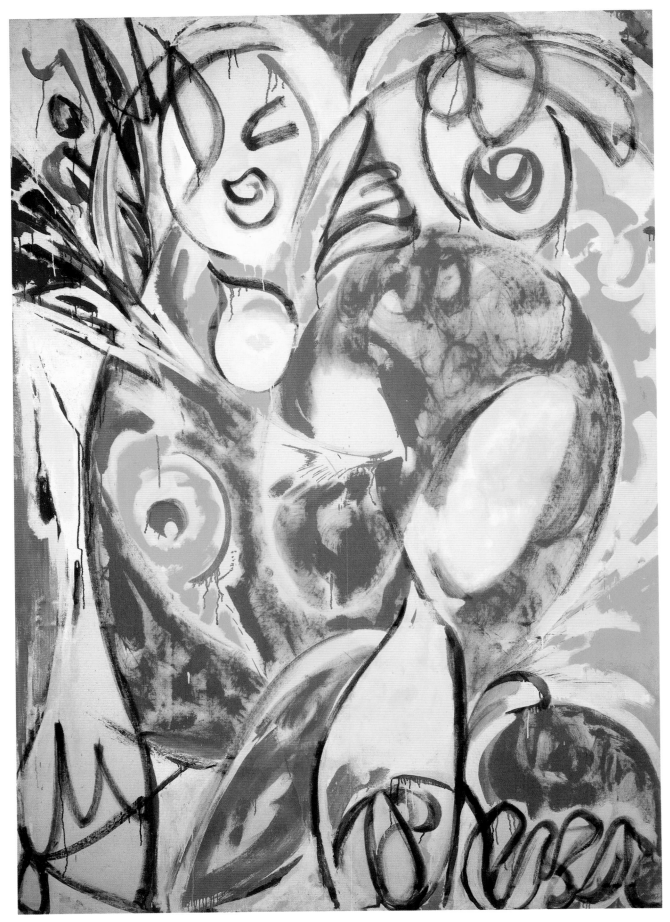

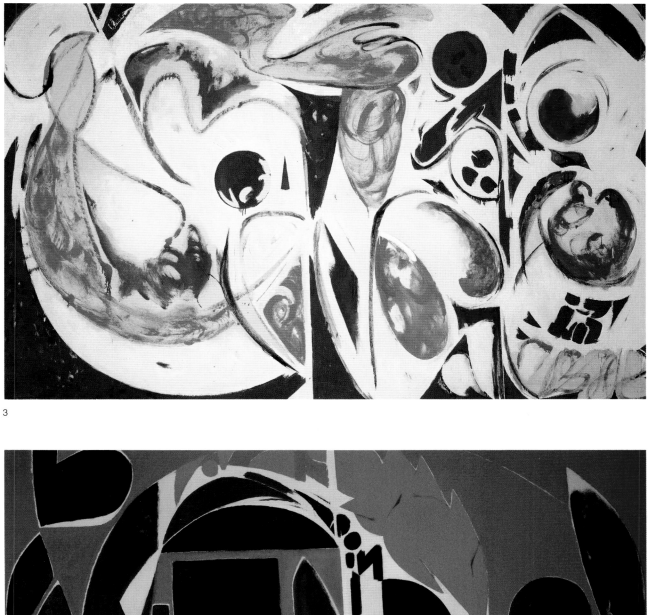

3

4

Like many creative individuals, Krasner tended to be inconsistent, and critics have come to radically different conclusions about her—some declaring that she was independent, others that she was dependent; some declaring that she needed to control, others that she desired to be controlled. Krasner was capable of continuing feuds for decades, but she could also inspire and maintain significant friendships throughout her life. Intelligent and well-read, she worried if she did not "forget enough" so that the ideas she encountered could later be absorbed into her own art.[3] Her long-term friend John Bernard Myers succinctly summed up her appeal to a variety of people in terms of "her wild gaiety" and her "sense of humor that was irresistible and irrepressible."[4]

Physically, Krasner embodied some of the same contradictions that were part of her personality. Her facial features were too strong to be considered conventionally attractive (even Pollock denigrated her appearance on a number of occasions), but she had such a beautiful body that she worked as a model at the Art Students League and as a fashion designer's model. Lillian Olinsey, a friend from the Hofmann School of Fine Arts, remembers being initially impressed, in 1937, with Krasner's sensu-

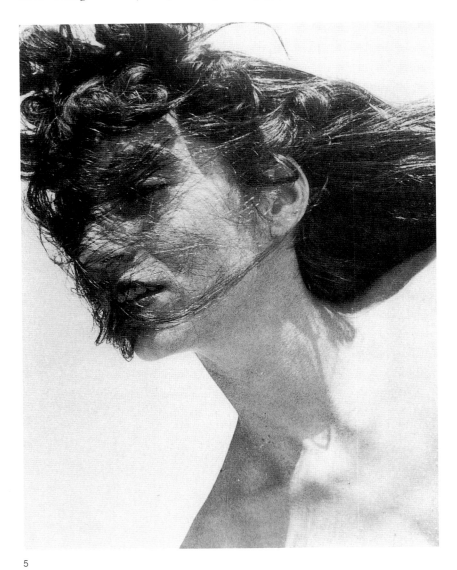

5. Lee Krasner, n.d. Photograph by Herbert Matter

5

ousness, recalling her as "both attractive and repulsive, a very striking individual . . . and a great presence."[5]

Krasner no doubt used her art as a way to resolve the various contradictions in herself. She was involved in a relentless search that entailed cycles of both creative and destructive periods. Because Krasner worked only when inspired, she was subject to long periods of inactivity followed by intensely productive times when she let go of everything in order to follow her inspiration. Sometimes she would stop for months and then begin again by cutting up old paintings and using them to create new collages.

Given the number of different approaches that Krasner used in her art, she sometimes appeared to be unsure of her direction. But when one considers the quality of the works themselves and their relationship to the styles she was critiquing, her series of changes was fully justified. In the 1940s she was learning to value her intuition as a worthwhile source for her art. After coming to terms with this aspect of herself, she carried on an aesthetic conversation with the other Abstract Expressionists during the 1950s. To the formalist art of the 1960s and early 1970s, she brought a wealth of experience, a wide emotional range, and an ability to play with formal elements and at the same time deal with profoundly important metaphors. Later she developed many of the tactics of the postmodernists, who were emphasizing the problems inherent in art as a mode of communication. Although always an Abstract Expressionist, she carried on a dialogue with a number of new styles. In this respect she learned from Pablo Picasso, who played with both past and present art as sources. But unlike Picasso, who comprehended the complexities of his aesthetic games and enjoyed them immensely, Krasner distrusted her own intelligence. In her art she attempted instead to trust her unconscious to lead her to what she regarded as true feelings rather than socially conditioned responses.

The abrupt changes in Krasner's style, coupled with her consistently voiced adulation of Pollock's paintings and tough criticism of her own work, were probably responsible for delaying the critical acceptance of her art. Slights and perceived injustices from critics tended to make her furious, but she transformed her anger into astute critiques of the art theories promoted by those who infuriated her. Her fights with the two major critics of Abstract Expressionism, Clement Greenberg and Harold Rosenberg, and her predilection for speaking her mind made her a force to be reckoned with, and often avoided. But as she told the critic Barbara Cavaliere in 1980: "Not having been a giant success in my life has been, in the end, a blessing. I can afford now to do as I wish. . . . So I'd like to take advantage of the situation and not predict what my next paintings will be."[6]

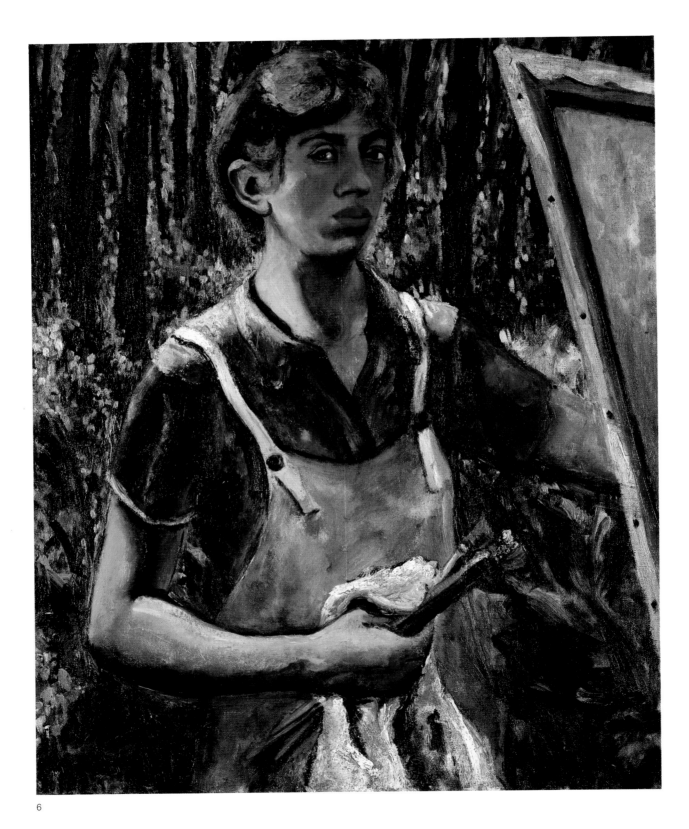

6

1 Lenore Krassner

One essential contradiction that continued throughout Lee Krasner's life was between her rootedness in a family of orthodox Russian Jews recently immigrated to Brooklyn and her urgent desire to be modern and international. Although she seemed to have already dispensed with her parochial background when she started attending Washington Irving High School in Manhattan during the early 1920s, it kept cropping up in her work and life as both a source of strength and a tremendous threat.

The girl born nine months after her mother was united with her father in Brooklyn was given the name Lena Krassner. Her father, Joseph Krassner, and her mother, Anna, had married when Anna was only eleven years old. Joseph had worked for a rabbi in a small village near Odessa, then followed Anna's brother to the United States, where he found work selling fish and produce. After she joined him in the United States, the nineteen-year-old Anna took charge of his small produce store so that he could focus on religious affairs.

Krasner remembered having been a religious child who regularly attended services, fasted on holy days, and learned to write (but not read) Hebrew.[7] Her exposure to Hebrew as well as to the other languages in her parents' household—including Russian, Yiddish, and a smattering of English—may have been one reason that she delighted in making up private languages in her paintings.[8] She later attributed her interest in calligraphy to the richly decorated books in the house, which included religious texts with elaborate scripts.

Even though Krasner recalled with pleasure some aspects of her childhood, the family was not a happy one. She reflected with some bitterness that the house was "like living in some little ghetto back in Stalingrad or somewhere."[9] Her mother was short-tempered, her father distant; and they both distrusted American culture. While her father retreated to the temple, her superstitious mother taught the children to be afraid of thunder and aware of spirits. Years later Krasner remembered thinking, at age five, that some strange being, "half man, half beast," had jumped over the banister and landed on the floor beside her.[10]

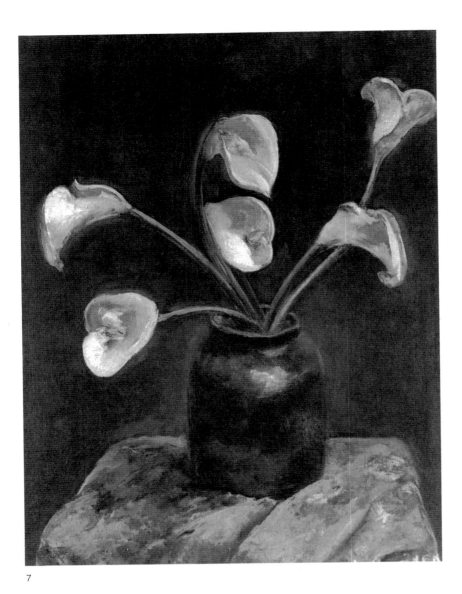

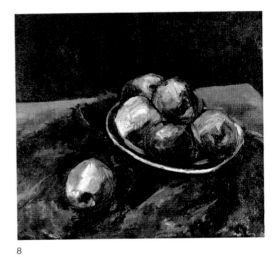

7

8

"Lenore," as the young Lena preferred to be called, was excited by the world around her. She later remembered the neighborhood as international—with French, German, and Eastern European families—and surprisingly rural. There were wildflowers in her backyard and a nearby farm with cows. Although Lenore was intrigued with learning, she was too rebellious and assertive to conform to traditional ways. "When I was twelve or thirteen," she recalled, "I crashed into the living room just as my parents were having tea with a doctor who was a distant relative and announced that I was through with religion."[11]

Like many first-generation Americans, Lenore wanted to become firmly entrenched in the dominant culture, so after attending high school she chose the conservative course offered at the Women's Art School of Cooper Union. Although she did study briefly in 1928 at the Art Students League, which was considered advanced if not radical, she returned to Cooper Union and then in 1929 was admitted to the reactionary National Academy of Design, where she took courses for four years.

7. *Easter Lilies*, 1930
Oil on canvas, 33¼ x 25¼ in. (84.4 x 64.1 cm)
The Estate of Lee Krasner; Courtesy Robert Miller Gallery, New York

8. *Still Life with Apples*, 1932
Oil on canvas, 18 x 19½ in. (45.7 x 49.5 cm)
Ronald Stein; Courtesy Robert Miller Gallery, New York

Krasner's lifelong determination to succeed is already evident in *Self-Portrait* (1930), which she painted entirely out of doors. 6 "I spent that whole summer," she reminisced, "out in Huntington, Long Island, where my family lived then, with a mirror nailed to a tree doing a self-portrait. I submitted it in the fall to the committee [at the Academy] so that I could get promoted to Life [drawing class] . . . and I made it, but only 'on probation.' Then my new instructor accused me of playing a dirty trick by pretending to have painted the picture outdoors when I had really done it inside. No amount of explanation helped."[12]

The assertive and unconventional *Self-Portrait* was clearly out of sync with the beaux-arts tradition promulgated by the National Academy. In it Lenore pictured herself as an ordinary, unidealized worker holding a paint-soaked rag and brushes in one hand while painting with the other. Although right-handed, she depicted herself painting with her left, thus reinforcing the metaphor of art as a mirror of reality. Paul Cézanne's influence is evident in the painting of her apron, and the handling of the background reveals her research into Impressionism. She pictured herself as strong and uncompromising but with a full, almost sensuous mouth and an abundance of copper-colored hair. Situated at the center of the canvas, she is both creator and model, the revealer of nature and its embodiment—fusing two different iconographic roles that in the Renaissance had been played by a male artist and his female model.[13]

Toward the end of her life Krasner remarked on the prescience of this work. "The self-portraits . . . make it clear that my 'subject matter' would be myself. The 'what' would be truths contained in my own body, an organism as much a part of nature and reality as plants, animals, the sea, or the stones beneath us."[14] This outdoor self-portrait established the theme of the self, which she would explore in many of her abstract pieces; the conflation of self with nature and the emphasis on the process of making art would also recur in her later enigmatic hybrids. The self-portrait's background, with its dense woods and field with many flowers, also establishes the artist's interest in the fecundity of nature, which would continue throughout her career. And, finally, in this work Krasner established the theme of herself *in* nature; later she would carry on a discourse concerned with the self *as* nature. Years afterward Krasner summarized the significance of this painting when she said, "I think I am still dealing with these same polarities that are in this portrait."[15]

Although Krasner remembered having been excited by her first visit to the Museum of Modern Art, New York, in 1930, her fascination with the art she discovered there did not become evident in her work at the National Academy. Her *Easter Lilies*, for 7 example, is a competent, yet conservative student exercise. Lenore may have been profoundly moved by both Matisse and Picasso, but coming to terms with Cézanne's late expressionism seems to have been the greatest challenge she permitted herself at the Academy, as her small *Still Life with Apples* testifies. 8

The year after graduating from the Academy, Lenore studied for a semester at Greenwich House with Job Goodman, who

encouraged students to copy the old masters. Given Krasner's emphasis on her own strength in *Self-Portrait,* it is not surprising that she chose to copy Michelangelo's robust, muscular, and almost androgynous nudes, which led to a series of drawings of her own heroic female nudes.

During this time Lenore was preparing to become a teacher by taking education courses at City College. She was also enjoying her new role as the girlfriend of Igor Pantuhoff, who had been a student at the Academy. A beguiling alcoholic and a White Russian who passed himself off as a cousin of the czar, Pantuhoff looked to many people like Errol Flynn. Lenore allowed him to transform her into his high-style consort, and he dressed her in dramatic black outfits with flamboyant accessories. Pantuhoff even designed special makeup for her, applying several shades of mascara or painting wide circles around her eyes. His portrait of her in profile indicates his fascination with her newfound glamour, as well as her innate belligerent sensuousness.

In order to support herself and Pantuhoff (at times when he could not obtain portrait commissions), Lenore worked at a number of places before becoming a silk-pajama-clad cocktail waitress at Sam Johnson's modest nightclub in Greenwich Village—a job that provided time for her studies as well as decent tips. Her intelligence proved an attraction to the writers who congregated there, including Lionel Abel, Maxwell Bodenheim, Parker Tyler, and Harold Rosenberg.

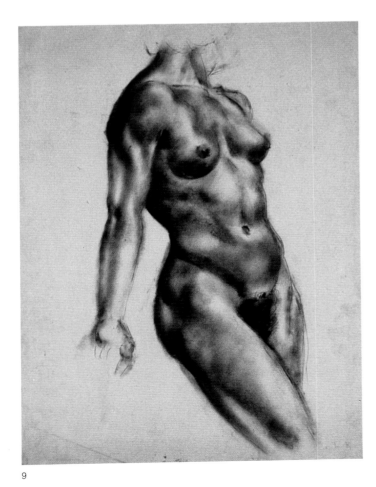

9

9. *Study from the Nude,* c. 1933
Conté crayon on paper, 20⅞ x 16 in.
(53 x 40.6 cm)
The Estate of Lee Krasner; Courtesy Robert
Miller Gallery, New York

10. Igor Pantuhoff
Portrait of Lee Krasner, c. 1932
Gouache on paper, 22 x 25 in. (55.8 x 63.5 cm)
Ronald Stein

10

A poet and burgeoning critic, Rosenberg became an important friend. In 1935 Lenore and Pantuhoff shared a large apartment on West Fourteenth Street with him and his wife. Krasner's association with Rosenberg has not received the emphasis it deserves. According to William A. Phillips, a colleague at *Partisan Review,* Rosenberg "was one of the great talkers of our time, at the beginning more a talker than a writer, though later his verbal gifts became more and more evident in his writing."[16] Known for dominating conversation, Rosenberg once confided to Abel "that in his view the best way to converse with someone . . . would be to knock him down and pour everything one had to say in his ear."[17] As a friend and apartment mate, Lenore was subjected to his constant barrage of ideas about politics as well as modern poetry and art from France.

In 1935 she and Rosenberg both became assistants in the Mural Division of the Federal Art Project (FAP), part of the Works Progress Administration (WPA). They were assigned the job of assisting the mural painter Max Spivak, who specialized in such subjects as clowns for children's hospitals. Spivak preferred to work alone but liked having them around, so the three of them would spend their afternoons discussing politics and intellectual trends. Through her association with Rosenberg and Spivak, Krasner became a wholehearted leftist, even though she claimed never to have joined the Communist party. She participated in political rallies and demonstrations, worked as a leader for the Artists Union, and was even arrested for her activities. As she recalled: "At the time . . . we used to be arrested quite regularly. It was an everyday affair."[18]

11

Because of the Depression many artists condemned capitalism as a failure, and they looked to socialism as a possible solution. But by the end of the 1930s leftists were being forced to choose between supporting the increasingly discredited Joseph Stalin or the far more liberal Leon Trotsky, who had been ousted from the USSR by Stalin. Because of his own disenchantment with state socialism, Trotsky disagreed with Stalin in believing that artists should never allow their work to become mere propaganda but should remain independent at all costs.[19] He thought that a radical approach to art in itself represented a commitment to a better world and that artists should create work as abstract and as radical as they pleased. Krasner certainly concurred with this belief, which no doubt was a major factor in her lifelong admiration of Trotsky. She recalled: "I, for one, didn't feel my art had to reflect my political point of view. I didn't feel like I was purifying the world at all. No, I was just going about my business and my business seemed to be in the direction of abstraction."[20]

The initial impact that Rosenberg, the WPA, and the Artists
11 Union made on Krasner's art is evident in *Fourteenth Street*, which records the rooftop view from her new quarters in the Rosenberg apartment. Instead of picturing a lofty skyscraper or a panoramic view of New York, Krasner depicted a bleak section of

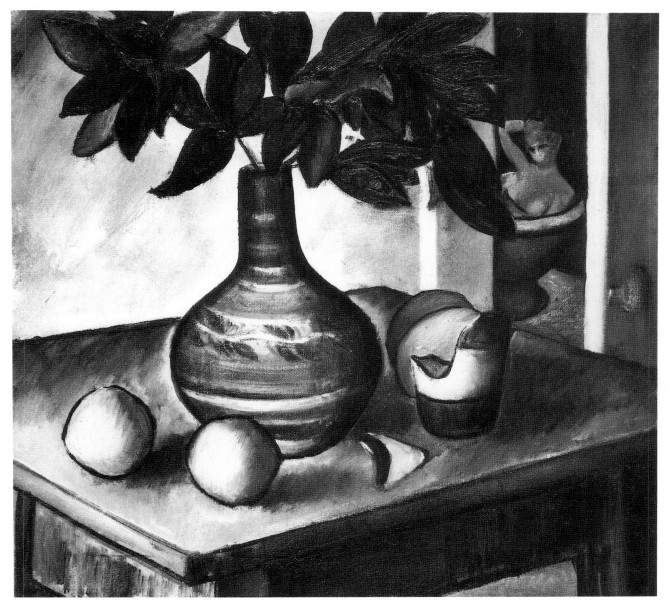

12

a partially torn-down building. The painting looks like an abstract version of an Edward Hopper watercolor, and it is similar to Hopper's work in presenting such a pessimistic image of the city.

The next year, 1935, Lenore created *Bathroom Door*. This small 12 work may reflect her feelings of vulnerability in the increasingly difficult relationship with Pantuhoff, who reacted to her newfound independence by having a number of affairs and by drinking even more. In this painting, which is generally Cézannesque, she established a poetic connection between a broken clay pot on the table and the crack in the door that reveals a voluptuous female figure in a bathtub. A broken pot in art traditionally signifies lost virginity; here the broken pot may allude to the fragmentation of the self. The break implied by *Bathroom Door* was acknowledged by the artist when, at some point in the late 1930s, she changed her name to Lee and anglicized *Krassner* by dropping the second *s*. The new name signaled a preference for the streamlined and modern, and her art would soon do the same.

11. *Fourteenth Street*, 1934
Oil on canvas, 25¾ x 21¾ in. (65.5 X 55.3 cm)
The Estate of Lee Krasner; Courtesy Robert
Miller Gallery, New York

12. *Bathroom Door*, 1935
Oil on linen, 20 x 22 in. (50.8 x 55.8 cm)
The Estate of Lee Krasner; Courtesy Robert
Miller Gallery, New York

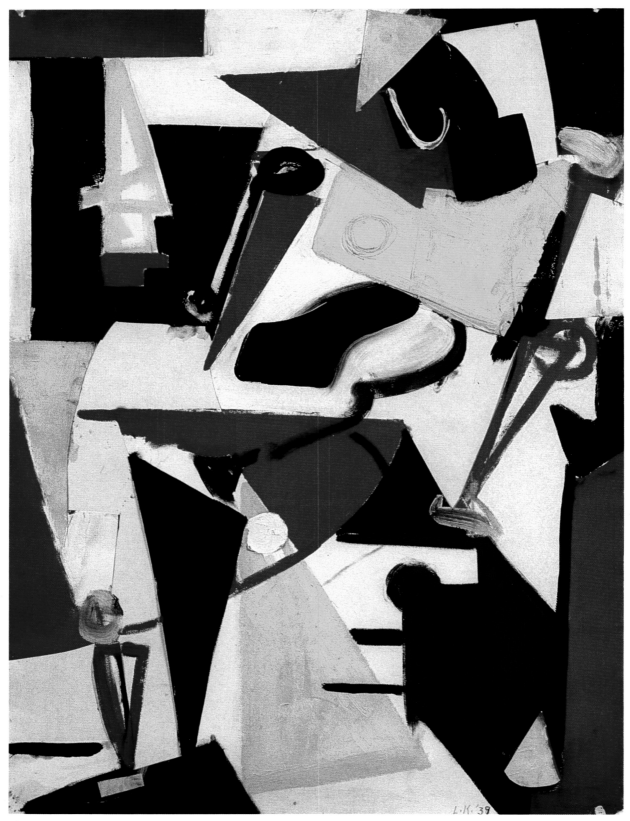

13

2 The Modernist

By the second half of the 1930s Lee Krasner was firmly set on a modernist course. Her conversations with Rosenberg as well as her association with Pantuhoff reinforced her move in this direction. Although Pantuhoff himself worked in a *retardataire* style, he favored modernist ideas and gave Krasner books on such European masters as Raoul Dufy, Matisse, and Picasso.[21] He may also have been the one who introduced her in the 1930s to the two most important avant-garde artists in America at that time: the Dutch immigrant Willem de Kooning and the Turkish Armenian Arshile Gorky. She soon became friends with both young painters and visited their studios frequently enough to absorb their mutual interest in Picasso's curvilinear Cubism.

A significant step in this quest for a modernist style was her brief flirtation with Giorgio de Chirico's style, which had influenced the Surrealists. Her interest in de Chirico was no doubt catalyzed by an exhibition of twenty-six of his early works, which was shown at the Pierre Matisse Gallery in late 1935.[22] *Gansevoort II*, a mysterious scene, reflects her fascination with this artist. It follows the composition of an earlier painting of the docks near where she lived, *Gansevoort* (Robert Miller Gallery, New York), but in *Gansevoort II* Krasner has used de Chirico's characteristically misaligned perspective to create a world out of kilter. 14

About the same time that she painted *Gansevoort II*, Krasner created a small, untitled Surrealist sketch of a great desert with a mountain range in the background. Two disembodied eyeballs are its main protagonists. One eyeball, which rests on the earth, "weeps" tears of blood vessels; the other, which levitates, appears to keep a landscape suspended in air through the sheer force of its vision. Central to this work is the idea of the power of sight and the connection between earthly and transcendent realms. 15

Krasner's modernist quest apparently received encouragement from Rosenberg, who was knowledgeable about modern poetry and its ways of freeing language from its customary utilitarian role. Through Rosenberg, Krasner came to admire the Symbolist poet Arthur Rimbaud. So great was her respect for his confessional

13. *Red, White, Blue, Yellow, Black*, 1939
Collage of oil on paper, 25 x 19⅛ in.
(63.5 x 48.5 cm)
Thyssen-Bornemisza Collection, Lugano,
Switzerland

14

15

prose poem *A Season in Hell* (1873) that in the late 1930s she wrote the following lines from it on her studio wall:

To whom shall I hire myself out? What beast must be adored? What holy image must be attacked? What hearts shall I break? What lie must I maintain? In what blood must I walk?[23]

All of the words were written in black except the question "What lie must I maintain?" which was in blue. About these lines Krasner commented: "They express an honesty which is blinding. I believe those lines. I experienced it."[24] So important to her was this section of Rimbaud's work that when Tennessee Williams began criticizing the French poet during a visit to her studio, she asked him to leave.[25]

Rimbaud wrote, "I ended up by finding sacred the disorder of my spirit,"[26] and this emphasis on cultivating a derangement of the senses in order to become a true visionary gave Krasner an itinerary for her own explorations of the new. Although she was later to credit Pollock with leading her from Hans Hofmann's emphasis on external nature to his own affirmation "I am nature," she had already made this transition in her studies of Rimbaud.[27]

In 1939 Krasner saw Picasso's masterly political painting *Guernica* at the Valentine Dudensing Gallery in New York, and the painting confirmed her new interests. She had already entered the Hans Hofmann School of Fine Arts on West Ninth Street, where she was learning the rudiments of the Cubist tradition. Receiving a scholarship had eased her entry into the school.

A German expatriate, Hofmann was unique in his having codified Fauvism and Cubism into a system that could be taught.[28]

14. *Gansevoort II*, 1935
Oil on canvas, 25 x 27 in. (63.5 x 68.6 cm)
The Estate of Lee Krasner; Courtesy Robert Miller Gallery, New York

15. *Untitled*, n.d.
Mixed media on blue paper, 12 x 9 in. (30.4 x 22.8 cm)
The Estate of Lee Krasner; Courtesy Robert Miller Gallery, New York

16. Still-life model at the Hans Hofmann School of Fine Arts, 1948
Photograph by Rudolph Burckhardt

His knowledge of modernist aesthetics had been acquired at first hand in Paris, where he became acquainted with Matisse, Picasso, and Robert Delaunay. In the late 1930s Hofmann's Friday lectures were attended not only by his students but also by various members of the art community, including the painters Gorky, de Kooning, and Pollock and the critics Greenberg and Rosenberg. Hofmann's lectures emphasized three essential factors: nature, the artist's temperament, and the limits of the medium. Each factor had its own laws, and no one had priority over any other. Hofmann counseled his students and members of his audience that colors interacted in a way that could be understood abstractly in terms of the "push-pull" between the hues. Instead of overlapping forms to suggest depth, he preferred students to create tensions between planes so that the inherent two-dimensionality of the canvas would be maintained.

He divided the school into three sets of classes, one each in the morning, afternoon, and evening. During the morning and evening sessions students drew or painted from the model; they studied still life in the afternoon. Students could enroll in any of the classes, and some, like Krasner, took both still-life and modeling classes.

Hofmann was careful to create sets for his students' still lifes that would make them deal with both positive and negative space; he spent hours creating elaborate assemblages for them to paint, 16 which included crumpled cellophane, construction paper, and whatever objects were at hand. Painting cellophane helped students understand that space is not a void but another aesthetic element that must be taken into consideration when creating a composition.

Within a year of starting classes at Hofmann's school, Krasner was painting accomplished, highly abstracted still lifes that reflect 17

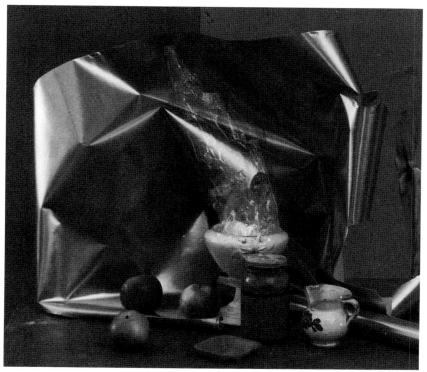

16

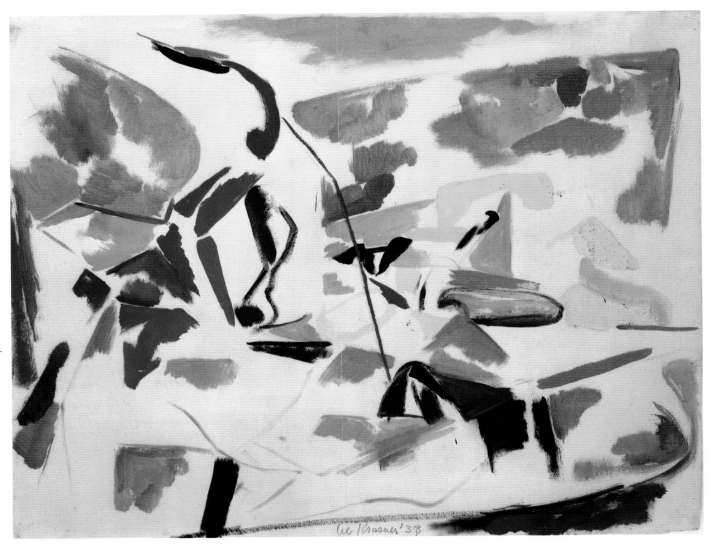

17

both Hofmann's teachings and the example of Matisse's early Fauve studies. These exercises show her to have been particularly intrigued with the French master's method of suspending touches of color in a sea of white. The overall luminosity of the work was enhanced by this approach, and color could be viewed both as a means for achieving an illusion and as a positive element in its own right.

Of far greater importance than her still-life paintings are the life drawings that Krasner made at the Hofmann School. In these works she quickly assimilated the rudiments of Cubism as well as Hofmann's emphasis on tensions achieved through the opposition of light and shadow, depth and flatness. In addition, she broke up the figure into abstract equivalents. Charged with energy, her nude studies not only fill the space of the drawing, they dominate it. In these works Krasner revealed a heightened awareness of the female form as a source of strength, an idea consistent with her own physical attributes and her powerful early Michelangelesque drawings of women.

Because she invested so much thought in her drawings, Krasner was particularly upset when Hofmann ripped one of them into four pieces and then rearranged the parts to demonstrate how

17. *Still Life,* 1938
Oil on paper, 19 x 24¾ in. (48.2 x 62.8 cm)
Whitney Museum of American Art, New York;
Purchase in honor of Charles Simon, with funds given by his friends from Salomon Brothers on the occasion of his 75th birthday, and with funds from an anonymous donor and the Drawing Committee

18. *Mosaic Collage,* 1939–40
Collage on paper, 18 x 19½ in. (45.7 x 49.5 cm)
David Anderson Gallery, Buffalo

tension could be heightened. Even half a century later she would become angry when discussing this incident or when recalling how Hofmann would take her charcoal and rework a section of a drawing she was working on.[29] She even refused to admit that this was his common practice.[30] Although feeling chastised by the fact that Hofmann had torn her drawing, Krasner heeded his example shortly thereafter when she cut up pieces of paper to make *Mosaic Collage*. Hofmann was evidently impressed with Krasner's progress. One day he commented to the class, "This [study] is so good you would not know that it was done by a woman."[31] Although she was obviously pleased by the tainted compliment, the slight to her gender rankled.

Having absorbed Hofmann's method, Krasner enriched it by conflating lush female figures with still life in a series of paintings from the late 1930s and early 1940s. These paintings, which have heretofore been regarded as pure still lifes, provided her an

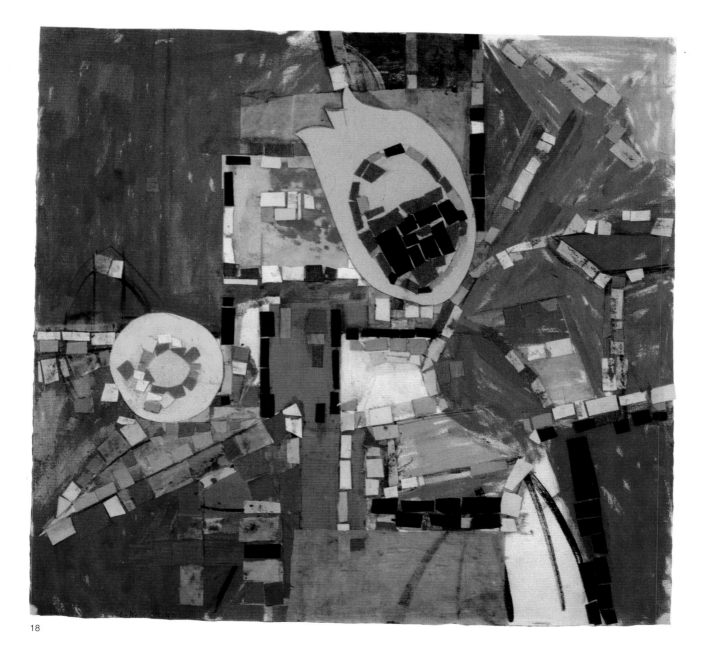

18

19 20

opportunity to elaborate on the female as still life and as a
symbol of fecundity. A prototype for them was Picasso's paint-
ings of Marie-Thérèse Walter in which his young mistress was
metamorphosed into both a still life and the landscape sur-
rounding her. One of Picasso's most enigmatic paintings in this
series, *Still Life on a Table* (Musée Picasso, Paris), was exhibited
in a 1939 retrospective at the Museum of Modern Art entitled
Picasso, Forty Years of His Art, where Krasner would have seen
it. She employed Picasso's cloisonné style of heavy black outlines
as well as his reliance on areas of pure color, but unlike Picasso
she built up heavily encrusted surfaces. In her works she blurred
the distinction between organic and geometric forms, at times
using trapezoids and triangles to suggest leaves and fruit. *Com-*
22 *position,* from 1939, represents the culmination of her experi-
ments. Although ostensibly representing a plant and a still life,
the forms take on the qualities of Krasner's nude studies, thus
becoming a strange, evocative personage.

Transforming the female nude into an abstracted still life may
have represented a way for Krasner to sublimate some of her anxi-
eties about her corroding relationship with Pantuhoff and her
changing values as she transformed herself from a fashionable
young girlfriend into a radical artist. In these paintings she was
able to present a more complex view of herself in relationship to
nature. Instead of simply seeing herself in nature, she viewed the
female form—an equivalent of herself—as metamorphosing into a
highly structured and largely abstract embodiment of nature.

In addition to working with Hofmann and being influenced by
Matisse and Picasso, Krasner became intimately acquainted with
the work of Willem de Kooning, at a time when he was resolutely
making only nonobjective paintings. De Kooning had been
working on a model for a large WPA-sponsored mural before

19. *Nude Study from Life,* 1939
Charcoal on paper, 24¾ x 19 in. (62.9 x 48.3 cm)
The Estate of Lee Krasner; Courtesy Robert
Miller Gallery, New York

20. *Seated Nude,* 1940
Charcoal on paper, 25 x 18⅞ in. (63.5 x 48 cm)
The Museum of Modern Art, New York; Gift of
Constance B. Cartwright

21. *Untitled,* 1940
Oil on canvas, 30¼ x 24¼ in. (76.8 x 61.5 cm)
John Eric Cheim, New York; Courtesy Robert
Miller Gallery, New York

being taken off the project because he was not a United States citizen. As a member of the Mural Division, Krasner was asked to complete this work for him. De Kooning gave her a life-size sketch and would visit her studio to unofficially monitor the work.[32] Unfortunately, the completed mural was lost, but it has been described as hard-edge, nonobjective, and reminiscent of art by the French painter Fernand Léger, with whom de Kooning had worked in 1935.[33]

Krasner's period of apprenticeship seemed to end in 1940, when she joined the American Abstract Artists (AAA), a group of painters that included many former Hofmann students. This group, established in 1937, was dedicated to creating international abstract art and subscribed to a number of different ideas—including Piet Mondrian's Neo-Plasticism, a generalized biomorphism, and even an abstract variation on Surrealism. Dismissed as too conservative by the Museum of Modern Art's director, Alfred H. Barr, Jr., these artists had to look elsewhere for support and originated the idea of holding annual exhibitions with catalogs. From 1940 to 1943 Krasner participated in these annual affairs, which were held in New York either at the Riverside Museum or the Fine Arts Galleries.

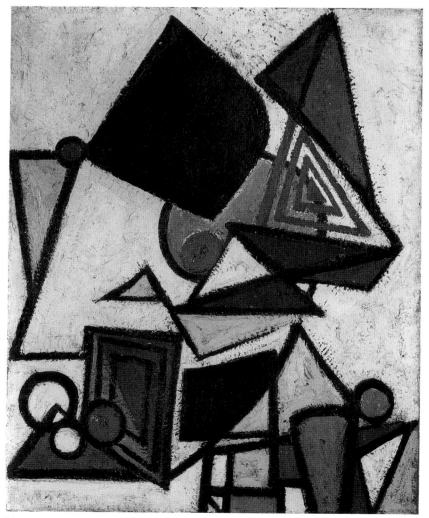

21

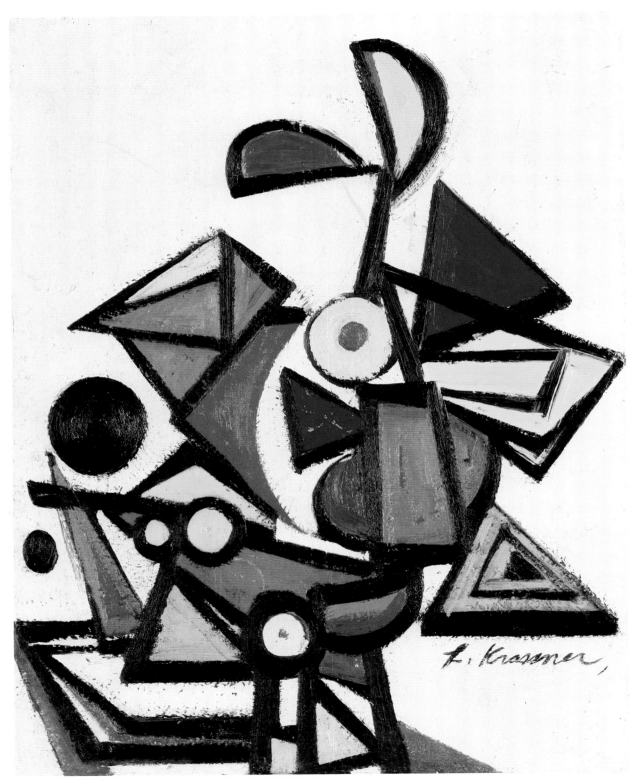

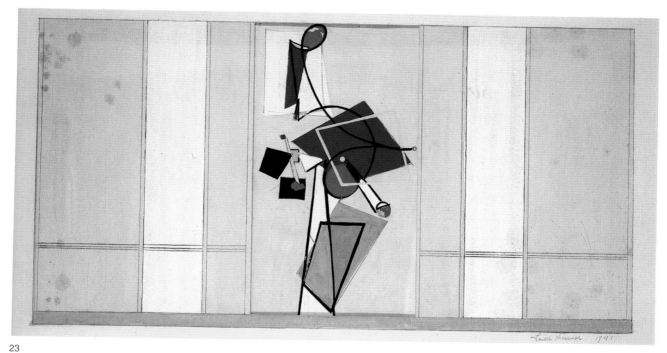

23

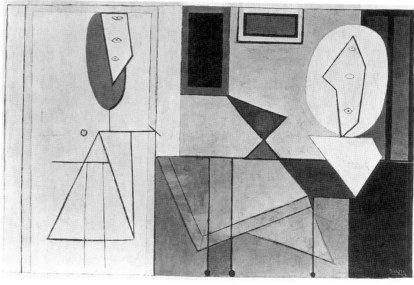

24

22. *Composition,* 1939
Oil on canvas, 30 x 24 in. (76.2 x 60.9 cm)
National Museum of American Art, Smithsonian
Institution, Washington, D.C.; Museum pur-
chase made possible by Mrs. Otto L. Spaeth,
David S. Purvis, Anonymous donors, and
Director's Discretionary Fund

23. *Mural Study for WNYC, Studio A,* 1941
Gouache on paper, 19½ x 29 in. (49.5 x 73.6 cm)
The Estate of Lee Krasner; Courtesy Robert
Miller Gallery, New York

24. Pablo Picasso (1881–1973)
The Studio, Paris, winter 1927–28, dated 1928
Oil on canvas, 59 x 91 in. (149.9 x 231.2 cm)
Collection, The Museum of Modern Art, New
York; Gift of Walter P. Chrysler, Jr.

In 1940 the AAA invited Mondrian, a recent immigrant to the
United States, to become a member, and both his art and his
presence in New York became important to Krasner. She took
great pride in her occasional encounters with this uncompro-
mising avant-garde artist. "I loved jazz and he loved jazz, so I
saw him several times and we went dancing like crazy."[34] She
also remembered escorting Mondrian through an AAA annual at
the Riverside Museum. When they came to her submission, a
Cubist still life, Mondrian remarked on her "strong inner
rhythm" and counseled her to maintain it always.[35] Although
such encounters with Mondrian had great significance for
Krasner personally, their influence on her art did not become
apparent until the end of the decade, when she created her Little
Image series.

Because of Krasner's association with the AAA as well as the general esteem for her work on the mural project, Burgoyne Diller, head of the New York City WPA/FAP Mural Division, asked her in 1941 to submit sketches for one of the few series of abstract murals to be commissioned in New York City. The site was the radio station WNYC, which was housed on the twenty-fifth floor of the Municipal Broadcasting Building. Already completed were murals by Byron Browne, Stuart Davis, Louis Schanker, and John Van Wicht. For this project Krasner created two series of abstract geometric studies in gouaches. But before

23 she had time to paint the mural, the United States' entry into World War II so bolstered the flagging economy that the WPA and the mural were canceled.

All of Krasner's mural studies reveal an in-depth knowledge of Picasso's work, and some in particular reflect an awareness of his

24 1927–28 painting *The Studio* (which Walter P. Chrysler, Jr., gave to the Museum of Modern Art) and of *The Painter and His Model* (1928), a more detailed work in the Sidney Janis collection. In her mural studies Krasner conflated the artist and model into a central unit, following her practice begun in the late 1930s of metamorphosing a nude into a still life.

The joining of the artist and model has an interesting background. In the Renaissance the customary practice had been for a male artist to appropriate the form of a nude or clothed female figure to serve as an image of nature and the artist's muse. When Krasner conflated the two, she was not a male artist wielding a phallic brush but rather a female artist representing a female figure as an embodiment of nature—and, by extension, an embodiment of herself.[36] Two years later, when she heard Pollock proclaim his own unconscious to be nature, his concept had a special resonance for her because she had already examined her own identification with nature. Of course, in her mural studies she presented this union as the subject of the picture rather than as a characterization of herself, and in these gouaches she continued to distance herself from her work by maintaining the intellectual formalities of Cubist abstraction.

In November 1941 Krasner and Pollock—together with the American painters David Burliuk, Stuart Davis, de Kooning, Walt Kuhn, and Nicholas Vasilieff—were invited to participate in a major exhibition to be held at the McMillen Gallery the following January. It was being organized by the artist, dealer, critic, and theorist John Graham. Believing that modern American art had progressed to the point that some of it could be effectively shown alongside its European counterparts, Graham also selected works by the Europeans Georges Braque, Matisse, and Picasso for the exhibition. Krasner was elated to be included in such an important group. She was also intrigued by Graham, a member of minor Polish nobility who passed himself off as a former Russian cavalryman serving the czar. Like Pantuhoff, Graham represented for Krasner international culture and the aristocratic side of Russian life, which her family lacked. In addition, Graham was a friend of Arshile Gorky's, a source of information

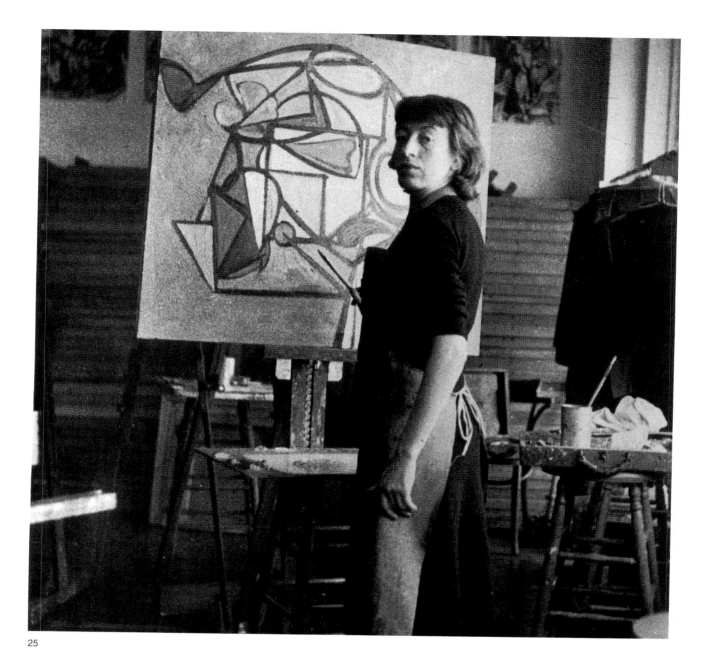

25

about the latest trends in Paris, and the author of *Systems and Dialectics of Art*, an important little book that Krasner had read when it was first published in 1937 and had found both intelligent and profound.

Although Graham was partly just a benevolent charlatan who aggrandized his past, he did help introduce a number of American artists—de Kooning, Gorky, Krasner, and Pollock—to the mysteries that were lodged within each one's unconscious.[37] He encouraged these artists to believe in themselves and to develop an iconography of the unconscious that would join elements of ancient and tribal art with organic forms, a Cubist vocabulary, and a reverence for ambiguity as a way to symbolize the great unknowns of existence. In a word, Graham empowered them to create highly personal works filled with universal meanings.

Since Krasner knew all of the Americans in the McMillen exhibition except Pollock, she set out to meet him that November of

25. Lee Krasner in Hans Hofmann's studio, early 1940s

1941 (they later realized that they had already met, briefly, in 1936). Discovering that he lived nearby, she went straight to his studio, not realizing that he allowed few people to visit. Taken aback by Krasner's forthrightness, Pollock allowed her to see his paintings, including *Birth* (c. 1938–41; Museum of Modern Art, New York), which would be shown at the McMillen Gallery exhibition.[38] According to Krasner's later recounting of the story, she was instantly overwhelmed by Pollock's genius and soon decided to devote herself to him and his art. However, Krasner's colleagues have recalled that her recognition of Pollock's significance was neither quick nor certain.[39] The two did begin to see a lot of each other soon after Krasner's initial visit, and she was able to employ Pollock on a new government project she was supervising that advertised the war effort. When the WPA disbanded in 1942, she headed up a propaganda program for the War Services Office, which was assigned to create displays for nineteen department-store windows in Brooklyn and Manhattan. (One of the few works to be photographed was *Cryptography*, which dealt with a subject that was important for Krasner's Little Image series, begun four years later.)

By the fall of 1942 Krasner was living with Pollock in his apartment on Eighth Street, in Greenwich Village, and she promptly started introducing him to her influential friends and associates in the art world. Probably because Krasner's relationship with Pantuhoff had ended as a result of her newly developed independence, she decided to remain in the background and promote Pollock. Playing this supportive role required enormous pertinacity, especially since Pollock was an alcoholic who would become hostile and even violent during his periodic binges. In order to get him away from his hangouts and into the country, where he would have a chance to dry out and work regularly, Krasner encouraged a move to Long Island. They married on October 25, 1945, in Manhattan and then moved to The Springs, on the outskirts of East Hampton.

Krasner met Pollock at a time when she was considered a formidable, well-connected young avant-garde artist and he was still an unknown loner. Because of her associations with the AAA, de Kooning, Gorky, Hofmann and his students, Rosenberg, and Rosenberg's friend the newly established art critic Clement Greenberg, Krasner was fully aware of the latest trends. Pollock, by contrast, was a protégé and close friend of the reactionary Regionalist Thomas Hart Benton, though in 1936 he was briefly an assistant to the Mexican muralist David Alfaro Siqueiros.

Many of Krasner's friends could not understand what she saw in Pollock. Even when his work was shown at Peggy Guggenheim's gallery and reproduced along with Krasner's in Sidney Janis's significant exhibition *Abstract and Surrealist Art in America*, they could not understand her fascination with his art and her willingness to slight her own career in order to promote this strange and difficult man. Krasner's fascination with Pollock was complex. Certainly his animal magnetism, coupled with his great emotional needs, appealed to her. Having lived with the alcoholic Pantuhoff, she was not only accustomed to the depen-

dency caused by substance abuse but also seems to have needed it. In addition, Pollock's art embodied Krasner's quest to come to terms with her own inner nature. She later concluded that Pollock's work corresponded to her own artistic goals: "I couldn't have felt that if I hadn't been trying for the same goal myself. You just wouldn't recognize it. What he had done was much more important than just line. He had found the way to merge abstraction with Surrealism."[40]

Krasner allowed her art to languish while she cultivated contacts for Pollock, worked in the Guggenheim gallery addressing announcements for his shows, and learned•to cook so that he would have a nurturing environment. In the process, she again transformed herself, from the fashionable modernist Pantuhoff had helped create into a far less self-assured woman who purposely eschewed glamour. But her relationship with Pollock also made her aware of this ongoing cycle of self-rejection and transformation. She thus began to search for a way to merge Lena, Lenore, and Lee into an intuitive, intelligent new identity.

26. Lee Krasner and Jackson Pollock in Pollock's studio, c. 1949
Photograph by Lawrence Larkin

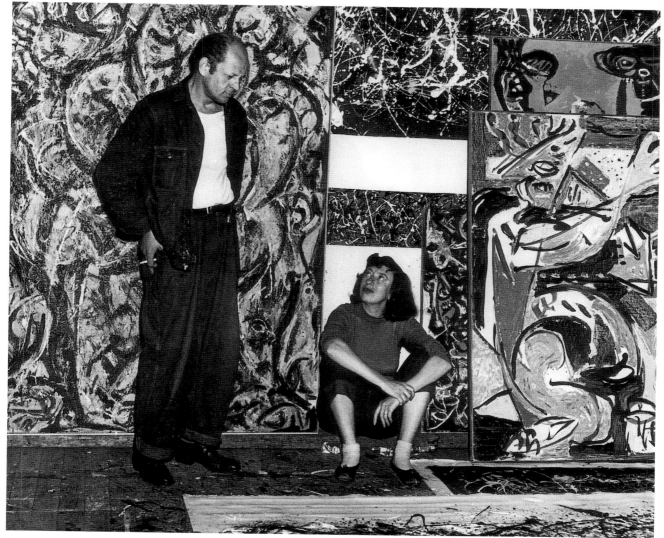

26

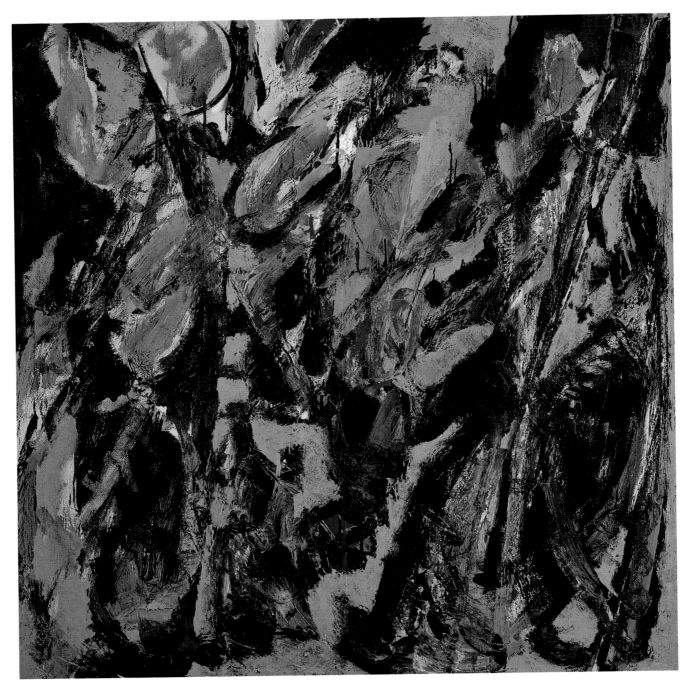

27

3 "I Am Nature"

In the 1940s and 1950s Krasner began the often painful experience of making her recalcitrant and little-understood unconscious—which she equated with nature—manifest in her art. In the process she reformulated both her way of working and her basic attitudes toward her work. Instead of struggling to make definitive statements, she began to create works that extolled process and change. Unlike many Abstract Expressionists who transformed their psychologically oriented art into a single, readily identifiable style—an approach that reinforced the romantic cult of the solitary genius—Krasner used her art as a way to carry on a conversation both with other artists and with her own past by restating in her paintings aspects of their work as well as of her earlier pieces. First she developed the confidence to accept the validity of her own experiences, then she carried on a discourse with Pollock's art, and then, beginning in the 1950s, she initiated a dialogue with other Abstract Expressionists as well.

Krasner searched for ways to plumb her unconscious, and she tried to keep her conscious mind from interfering with her goal to be intuitive and spontaneous. The conflicts between received ideas and intuitive convictions and between self-destruction and self-aggrandizement are apparent in many of her paintings of this period. Beginning in the 1940s both Krasner and her art underwent dramatic changes as a result of her close relationship with Pollock and his art. Just as the brilliant, colorful, witty, and belligerent young woman became the plain, supportive, possessive, and at times hostile wife,[41] so the artist who had once cultivated the newest styles of international art began to create thick gray slabs that embodied her inability to formulate a vital sense of self.

Krasner's new life required fortitude and pragmatism. The Pollocks moved to a simple frame house in The Springs that had neither bathroom nor central heating, though it did have electricity and a wet sink in the kitchen. Their funds were meager, their living primitive, and at times friends worried that they might not have enough money for food or even for wood to heat the stove.[42] They raised gardens to supplement their food supply, and

27. *Volcanic,* c. 1951–53
Oil on canvas, 48 x 48 in. (121.9 x 121.9 cm)
The Estate of Lee Krasner; Courtesy Robert
Miller Gallery, New York

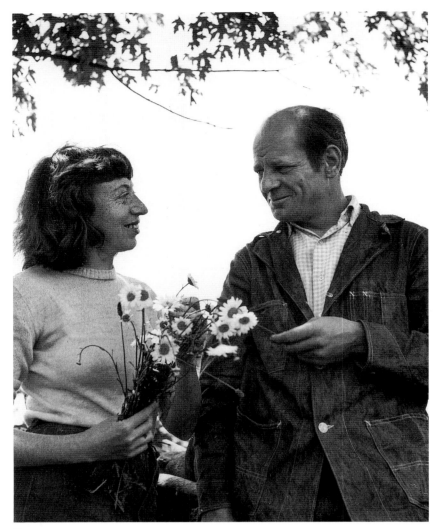

28

fortunately both found gardening enormously satisfying. Both Krasner and Pollock enjoyed the fantastic in nature as much as the Surrealists did.[43] She decorated the house with a great variety of dried flowers, gourds, fruits, and vegetables, and throughout her life she continued to surround herself with unusual minerals and shells as well as a wealth of plants.

Except for Pollock's bouts of drinking and the couple's infrequent trips to New York, their life was a quiet one. Lacking a car, they had to use bicycles or beg rides from neighbors, though later Pollock bought an antiquated Model A and would venture into the woods or go to town by himself, leaving Krasner alone. Their entertainment usually consisted of swimming and walks through the woods or along the beach. And there were periods of reflection when, according to Krasner, they would just "sit on the back porch and look at the light."[44]

The Pollocks' decision to live in The Springs, a small farming and fishing village in the East Hampton township, had been carefully considered. The Springs was a working-class community, but it bordered East Hampton, where prominent New Yorkers summered and artists had built studios for over a century. Also, many immigrant European artists spent time during the 1940s in

28. Lee Krasner and Jackson Pollock, The Springs, c. 1943–45
Photograph by Wilfred Zogbaum

either East Hampton or nearby Amagansett, thus enabling the Pollocks to remain in close contact with an elite international vanguard.

Because of her new priorities—to care for Pollock and to put the house in order—Krasner spent little time making paintings between 1942 and 1946. And when she did, she had to work in the living room because Pollock was using the upstairs bedroom for a studio. The lack of a private studio may have been a key factor in what she called her "blackout period." Because Pollock usually slept until noon, Krasner began painting in the morning. She preferred daylight because that is the time when color is most true, and she needed privacy to begin the slow, painful process of courting her unconscious. It surfaced intermittently in the few visionary works that trickled out during this period, and finally began to appear in full force in the Little Image series painted during the late 1940s. The first extant work expressing Krasner's interest in cultivating her inner nature is *Igor*, painted in 1943, 29 four years after Igor abandoned her. The blue in the picture alternates between foreground figure and background space, adhering to Hofmann's theory of push-pull but in a new and totally nonacademic manner, with the forms creating overlapping patterns as they swoop, glide, and pirouette. *Igor* has the same energy as Pollock's contemporaneous pieces, and its lyricism anticipates his later drip paintings. Examining the surface of this painting reveals that its grace was achieved at a cost. The layers of pentimenti and passages of thick, viscous paint belie Krasner's apparent spontaneity and expose her hesitations and thoughtful reassessments.

In *Image Surfacing* all the customary elements of Krasner's ear- 30 lier geometric abstract style have been transposed into a new key: the hybridized still-life figure that she once favored has become an enigmatic personage with a great vertical eye. This is notable for being the first appearance of the inner eye ("I"), representing a self, that was to haunt many of Krasner's works throughout her life. The work is definitely Abstract Expressionist in terms of the heightened drama created by its spontaneously applied brushstrokes.

Krasner's third important work to survive her blackout period is *Blue Painting*. Although it initially appears totally nonobjec- 31 tive, prolonged inspection reveals at its center a flower in profile, delineated in white. This motif had occurred in Krasner's earlier *Mosaic Collage*, and it continued to be an important element in 18 many of her later works. In *Blue Painting*, Krasner reinterpreted Pollock's conflated imagery, and her work makes a compelling comparison with his *Night Mist* (1944; Norton Gallery of Art, West Palm Beach, Florida). In both paintings the background impinges on the foreground, at times overwhelming it. Forms are not allowed to be discrete; each one seems to be affected by its surroundings. Even though *Blue Painting* is a forceful work, its power derives from Pollock's example. The overlay of white calligraphic strokes, for example, has its origin in his work, thus making *Blue Painting* a qualified achievement.

In 1946 Krasner began to accept her own intuition in a series of works contemporary with Pollock's first allover paintings. It is difficult to untangle the give and take between Krasner and Pol-

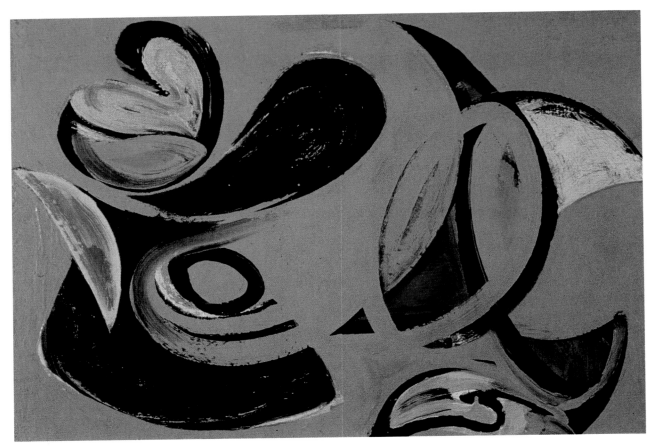

29

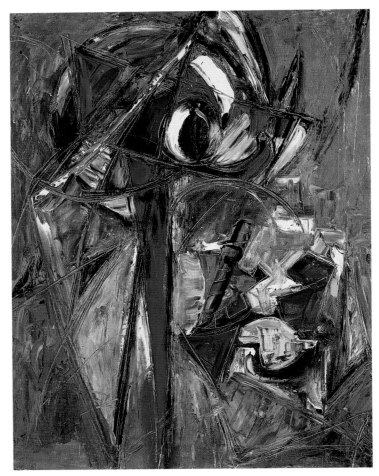

30

29. *Igor*, 1943
Oil on canvas, 16½ x 24½ in. (41.9 x 62.2 cm)
Private collection

30. *Image Surfacing*, 1945–46
Oil on canvas, 27 x 21½ in. (68.5 x 54.6 cm)
The Estate of Lee Krasner; Courtesy Robert
Miller Gallery, New York

31. *Blue Painting*, 1946
Oil on canvas, 28 x 36 in. (71.1 X 91.4 cm)
Anna Marie and Robert F. Shapiro; Courtesy
Robert Miller Gallery, New York

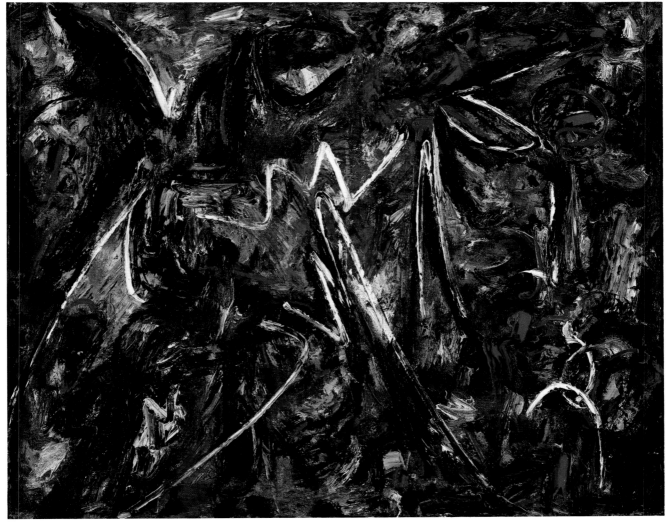

31

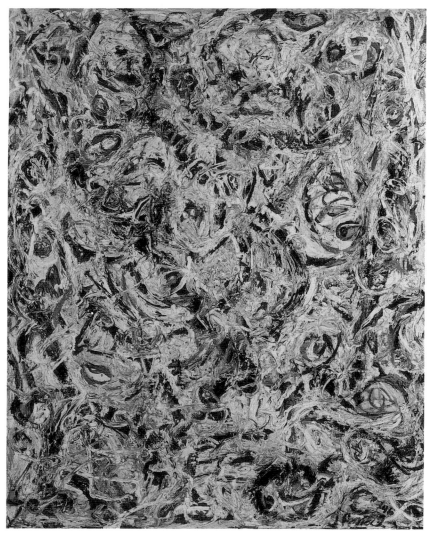

32

lock at this important time, when he first conceived compositions in terms of an allover field. His new mode is evident in *Eyes in the Heat,* as Krasner's is in her first Little Image paintings. Her contribution to the origination of allover painting was probably more a supportive than an inventive one: she paid Pollock the great compliment of first accepting his new schema and then personalizing it in her own work. Thus she corroborated the importance of this new development and encouraged Pollock to continue the innovations that led to his famous drip paintings.

The critic Barbara Rose has divided Krasner's Little Image series into three groups, beginning with the mosaics, then the webs, and finally the grids.[45] Although Rose's terms are entirely adequate, I prefer to use the terms *traceries* and *hieroglyphs* for the last two categories, in order to emphasize both their organization and their implicit meaning. Whereas the first two groups, the mosaics and traceries, developed out of Pollock's work, the hieroglyphs represented a significant new contribution by Krasner.

Although Krasner called all three groups "hieroglyphs" in 1965, she apparently decided in 1973, when Marcia Tucker was curating the exhibition *Lee Krasner: Large Paintings* for the Whitney

32. Jackson Pollock (1912–1956)
Eyes in the Heat, 1946
Oil on canvas, 54 x 43 in. (137.1 x 109.2 cm)
The Peggy Guggenheim Collection, Venice

33. *Shellflower,* 1947
Oil on canvas, 24 x 28¼ in. (61 x 71.7 cm)
Barbara and John Weisz; Courtesy Robert Miller Gallery, New York

Museum of American Art, to settle on the term Little Image paintings, which she may have used in the late 1940s, at the time they were made.[46] This seemingly casual approach to titling works of art provides an important clue to Krasner's attitude toward painting. Although she and others would suggest titles for specific works, she took responsibility for those titles, which are significant aesthetic components of her work, not merely convenient labels. This mode of naming is entirely consistent with Krasner's intuitive way of working, in which meaning could not be determined beforehand and had to surprise her. The content of the art was accepted by the artist rather than consciously initiated by her; it was a genuinely new creation rather than merely the illustration of an idea.

In her early mosaic painting entitled *Noon*, Krasner created an equivalent to Pollock's *Sounds in the Grass: Shimmering Substance* (c. 1946; Museum of Modern Art, New York). *Noon* brings the unconscious into the realm of art through the metaphorical presentation of this little-understood realm as a brightly lit field of flowers seen at midday. In this work, as in *Shellflower* and *Nightlife* (both 1947), Krasner reinterpreted Matisse in terms of Pollock's schema.

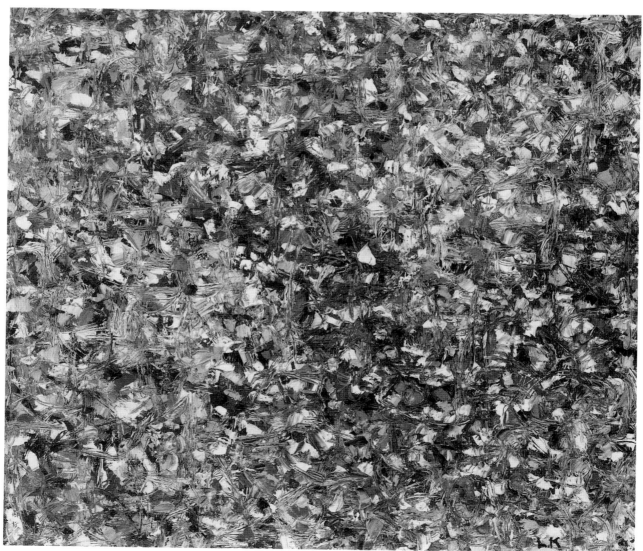

33

Whereas Matisse frequently equated blossoms with individual strokes of paint so that they became a brightly colored bouquet of abstract forms, Krasner used paint strokes to represent both themselves and a mirage of the unconscious mind. In *Nightlife* the metaphorical aspect of her style is particularly evident in the touches of pure color that serve as a carpet of floral shapes overlain with fine threads of paint, implying richness, fecundity, and luxuriance. Krasner's early mosaic paintings received an impetus from two mosaic tables that she made in 1947. Using pieces of tesserae that Pollock had collected for work he had done for the WPA in about 1938–41, Krasner created two round tables, each forty-eight inches (121.9 cm) in diameter. Iron wagon-wheel rims served as armatures for both pieces. In addition to tesserae, Krasner employed a variety of readily available materials, including pieces of broken glass, old coins, shells, pebbles, keys, and her own costume jewelry. The allover composition had a number of competing foci that resembled the eye or egg shapes Krasner began to use a decade later.

In 1948 Bertha Schaefer included one of the tables in the exhibition *The Modern Home Comes Alive*. It was featured in a room designed by the architect Edward Durrell Stone, which also

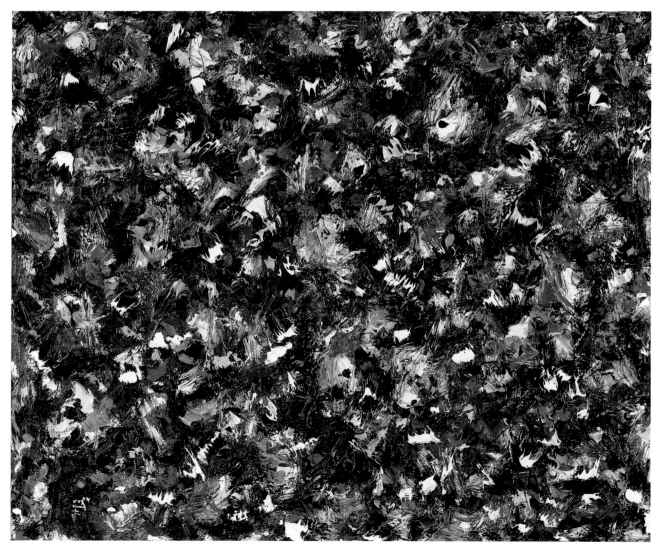

34

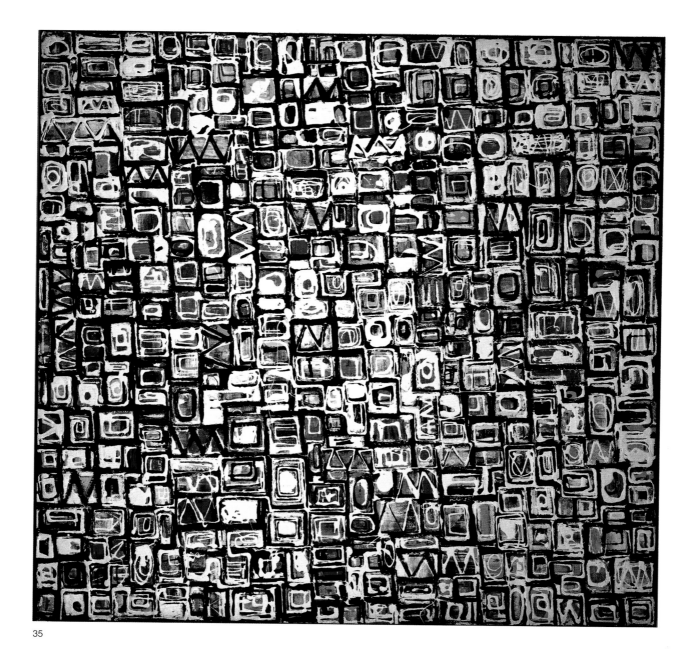

35

34. *Nightlife*, 1947
Oil on linen, 20¼ x 24 in. (51.4 x 61 cm)
Private collection; Courtesy Jason McCoy, Inc.,
New York

35. *Painting No. 19*, 1947–48
Oil and enamel on Masonite, 32¼ x 34¼ in.
(81.9 x 86.9 cm)
Gordon F. Hampton Family; Courtesy Robert
Miller Gallery, New York

contained furniture by Jens Risom and Wharton Esherick as well as paintings by Marsden Hartley and a number of lesser-known artists. The table was a great success, and Krasner's name was mentioned in reviews in the *World-Telegram, New York Herald Tribune, New York Times,* and *Architectural Forum.*[47]

In *Continuum* (1947–49) Krasner refined Pollock's drips to a [89] delicate tracery of black-and-white threads that form a cohesive and seemingly impenetrable interlace. The work suggests a *horror vacui* similar to that in the Celtic manuscript illuminations she admired. Krasner also relied on the discoveries she had made in producing the mosaic tables. For all its ingenuity, however, *Continuum* still looks timid when seen next to Pollock's drips. Her carefully marshaled tracery seems to indicate that Krasner was not comfortable with the uninhibited freedom of the drip paintings.

Krasner's major contribution to the allover picture rests in the third group of Little Images, the hieroglyphs, which feature an

interlocking grid ultimately derived from Mondrian's early Pier and Ocean series[48] and also related to Joaquín Torres-Garcia's grids as well as Adolph Gottlieb's Pictographs. Her hieroglyphs embody her serious reappraisal of Pollock's allover technique and an important critique of his drip paintings. If Pollock's drip paintings can be said to recall paleolithic cave painting in their freedom from rigorous boundaries and their emphasis on overlapping forms, Krasner's hieroglyphs can be called neolithic, for in them she invokes the demarcated fields that characterized early agrarian cultures. In some hieroglyphs Krasner codified Pollock's drips as discrete signs.

Krasner's hieroglyphs, consisting of discrete elements regularly distributed across her canvases, suggest a language in the process of formation. In *Painting No. 19* some of the abstract forms begin to look like letters: zigzags resemble *N*'s, *M*'s, and *W*'s; circular shapes, *O*'s and at times *D*'s. In other paintings the abstract forms seem to constitute a special pictorial language, which comprises elements such as chevrons, zigzags, and Greek keys. By

35

36

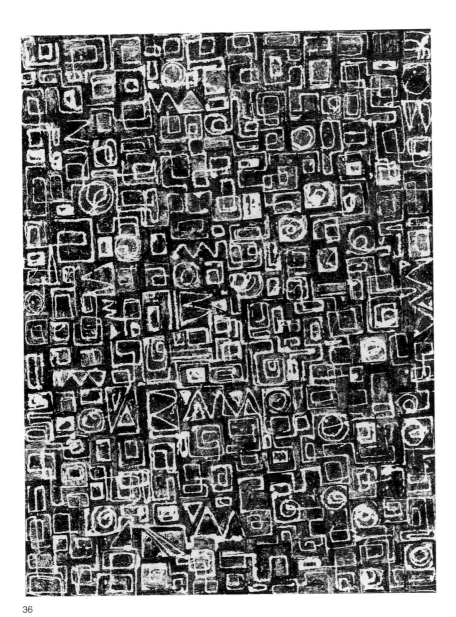

36. *Composition,* 1949
Oil on canvas, 38 x 28 in. (96.5 x 71.1 cm)
Philadelphia Museum of Art; Gift of the Aaron
E. Norman Fund, Inc.

36

presenting a series of signs without the necessary references for decoding them, Krasner established the abstract principle that art is a form of communication rather than providing a specific communiqué. In a few works she painted a series of abstract signs over a tracery of drips, creating the effect of an incipient language blocking a deeper and perhaps unconscious layer.

In the hieroglyphs Krasner may have been using an abstract language to work out her own complex feelings regarding her largely neglected Jewish heritage. In this respect she paralleled her fellow Abstract Expressionists Mark Rothko and Barnett Newman, who found Friedrich Nietzsche's tragedy and Edmund Burke's sublime effective models to follow in communicating their own intense feelings about the death camps and the after-effects of World War II.[49] Krasner was apparently oblivious to the potential significance of her mysterious writing until many years later, when curator Marcia Tucker pointed out strong affinities between Krasner's approach to painting and the way of writing Hebrew from right to left.[50] Although Krasner had studied Hebrew as a child, she soon forgot how to write it. Her reenactment of its basic orientation in her art may connote a significant tension between wanting to bring Hebrew (and, by extension, her Jewish identity) to consciousness and trying to keep it repressed.

At the same time that Krasner was assimilating Pollock's allover style, as exemplified first in his Sounds in the Grass series and later in his drip paintings, she was also making it more disciplined through the use of grids. These are incipient in *Abstract No. 2*, of 1946–48, and fully apparent in a number of works from 1948 and 1949. The desire to control in her own art Pollock's extreme spontaneity paralleled her need to help him maintain his relatively long period of sobriety from 1948 to the fall of 1950. In the early 1950s, when Pollock went through a severe psychological crisis—occasioned by his return to drinking, by his resumption of using figurative elements in his black-and-white works, and by his profound concern about sustaining his leading position in the New York vanguard—Krasner experienced a similar plight. But whereas Pollock's crisis was ultimately debilitating, hers became the basis for a new mode of working. This period of intense doubt—initiated by questioning her abilities and destroying a number of old works—shattered her self-image and made possible a new artistic formulation of herself.

In 1950, in anticipation of a solo exhibition the following year at the Betty Parsons Gallery, Krasner began making a series of "personages" similar to her single effort of 1947, *Promenade,* which was based on Pollock's *Mural* (1943; University of Iowa Museum of Art). Quickly becoming disenchanted with these works, she destroyed them and moved in an entirely different direction, creating paintings that related to work from her AAA period. These geometric abstractions of the early 1950s reinterpreted Mondrian and Josef Albers in a more painterly manner, using pentimenti to indicate the importance of process and the tentativeness of any one solution. In some of her Mondrian-

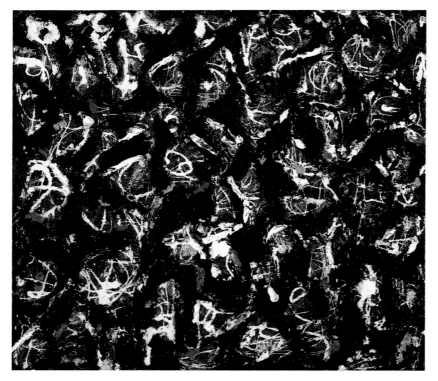

37

38

37. *Untitled,* 1949
Oil on composition board, 48 x 37 in.
(121.9 x 93.9 cm)
Collection, Museum of Modern Art, New York;
Gift of Alfonso A. Ossorio

38. *Abstract No. 2,* 1946–48
Oil on canvas, 20½ x 23¼ in. (58.9 x 52 cm)
Instituto Valencia de Arte Moderno, Centro
Julio Gonzalez, Valencia, Spain

39. *Promenade,* 1947
Oil on board, 30 x 48 in. (76.2 x 121.9 cm)
Private collection; Courtesy Robert Miller
Gallery, New York

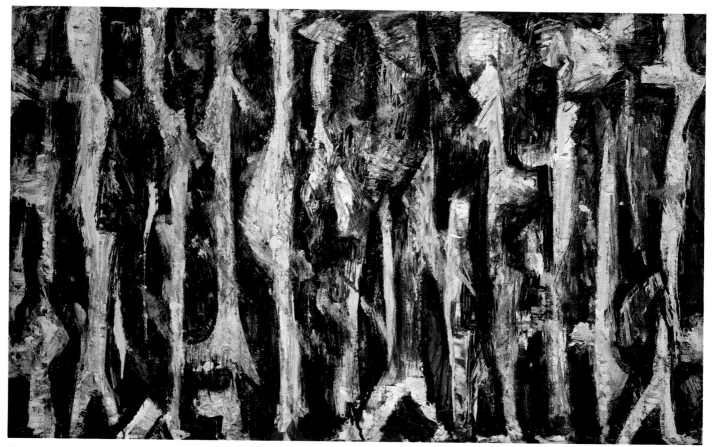

39

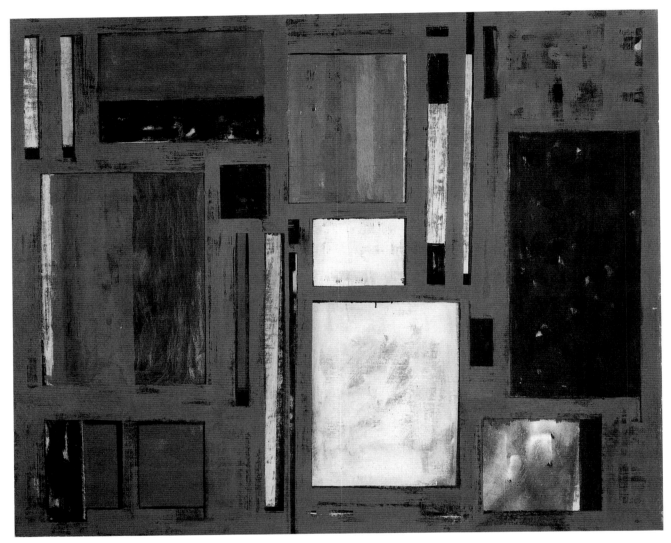

40

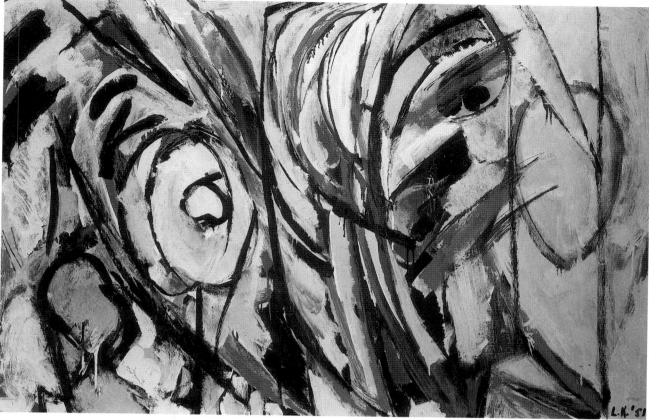

41

inspired works, background is as important as foreground, and the two oscillate, creating an important sense of tension.

These works acknowledge, in addition to Mondrian and Albers, the importance of Rothko's soft-edge veils of color and Hofmann's use of squares of construction paper to determine how certain forms and colors could intensify a composition. Although these large abstractions were shown at the Parsons Gallery in 1951, they did not satisfy Krasner, and she later destroyed all but two of them. She continued to work on one of them, *Equilibrium*, from 1951 until 1953 and was apparently 40 unable to let go of this style even though it received mixed reviews. The title *Equilibrium* may represent more a desire than a reality, signifying her need to retrieve aspects of her art that predated Pollock and to integrate them into her current work.

This retreat to geometric abstraction did not prevent Krasner from occasionally making improvisational works that exuded as much force as *Image Surfacing*—notably *Ochre Rhythm* and *Vol-* 30, 41, 27 *canic*. *Ochre Rhythm*—in which Krasner conflated egg, eye, breast, and plant forms—prefigures the iconography of her work from the late 1950s. *Ochre Rhythm* and the later works point to Krasner's interest in growth and nurturance, an interest also evident in *Volcanic*, in which an incipient egg shape fills the center of the canvas.

40. *Equilibrium,* c. 1951–53
Oil on canvas, 46 x 58 in. (116.8 x 147.3 cm)
The Estate of Lee Krasner; Courtesy Robert
Miller Gallery, New York

41. *Ochre Rhythm,* 1951
Oil on canvas, 37½ x 58 in. (95.3 x 147.3 cm)
Private collection; Courtesy Robert Miller
Gallery, New York

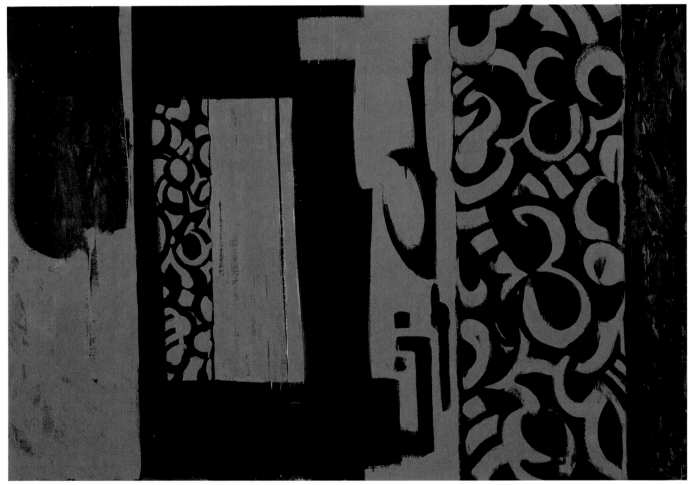

42

4 Collages and Other Conversations

After the Parsons exhibition, Krasner made a series of automatic black-and-white works on paper, derived in part from Pollock's 1951 succession of huge drawings in black paint on canvas. But Krasner soon grew dissatisfied with these works as well, as she related in an interview with Barbaralee Diamonstein:

It started in 1953—I had the studio hung solidly with drawings, you know, floor to ceiling all around. Walked in one day, hated it all, took it down, tore everything and threw it on the floor, and when I went back—it was a couple of weeks before I opened that door again—it was seemingly a very destructive act. I don't know why I did it, except I certainly did it. When I opened the door and walked in, the floor was solidly covered with these torn drawings that I had left and they began to interest me and I started collaging. Well, it started with drawings. Then I took my canvases and cut and began doing the same thing, and that ended in my collage show in 1955.[51]

Long after the completion of this collage series, Krasner called this act of aggression against herself "a form of clarification . . . [and] a form of growth."[52]

Krasner's creation of the collages may also have been stimulated by the examples of her friend Anne Ryan and her long-esteemed hero Matisse. Krasner remarked on Ryan's "lyric sensory images,"[53] and her collages may represent an alliance of Ryan's own diminutive and highly personal collages with the monumentality of Matisse's late paintings and découpages. Krasner's interest in Matisse is documented in her painting *Blue* [42] *and Black,* in which she created an abstract equivalent to the open-window-and-patterned-curtain motif in Matisse's late paintings. Whereas Matisse was investigating ideas concerning inside versus outside and depth versus flatness, Krasner was transforming the window-drapery-calligraphy panel in her painting into a smaller mirror image of the painting itself. This mirroring recalls Picasso's famous *Girl before a Mirror,* which is a psycho- [43] logical portrait of Marie-Thérèse Walter looking inside herself as

42. *Blue and Black,* 1951–53
Oil on canvas, 58 x 82½ in. (147.3 x 209.5 cm)
Museum of Fine Arts, Houston; Museum
purchase with funds provided by the Sarah
Campbell Blaffer Foundation

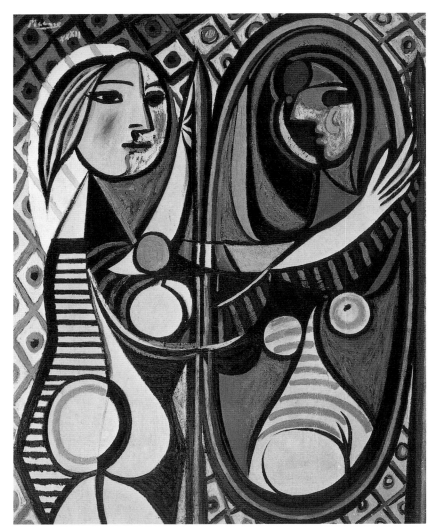

43

she gazes at a mirror. The fact that *Blue and Black* joined aspects of work by Matisse and Picasso with her own interest in preconscious language and her preference for boldly decorative work made clear the extent of Krasner's ambitions. She wanted not only to deal with a psychologically based content but also to integrate that content into forceful, arresting compositions.

44 In *Black and White,* one of her first collages made of her own cut-and-torn drawings, Krasner included an enigmatic personage. The right-hand section of the collage may refer to Picasso's *Girl before a Mirror,* to his pictures of artists and models, and to his illustrations for Honoré de Balzac's *Le Chef d'oeuvre inconnu*— all of which deal with the theme of translating the external world into the new and highly personal language of abstract art.

The same year that Krasner started making these collages, she 45 also began to focus on urban experience, as in *The City,* an apocalyptic work filled with exploding forms. A number of twentieth-century artists—including the Italian Futurists, the American John Marin, and Mondrian—had presented the modern city positively. Krasner's city pictures, however, build on Fernand Léger's more negative view of the urban experience, as in his painting *The City* (Philadelphia Museum of Art), with its anonymous

43. Pablo Picasso (1881–1973)
Girl before a Mirror, Boisgeloup, March 1932
Oil on canvas, 64 x 51¼ in. (162.5 x 130 cm)
The Museum of Modern Art, New York; Gift of Mrs. Simon Guggenheim

44. *Black and White,* 1953
Collage on paper, 30 x 22½ in.
(76.2 x 57.2 cm)
Robert Miller Gallery, New York

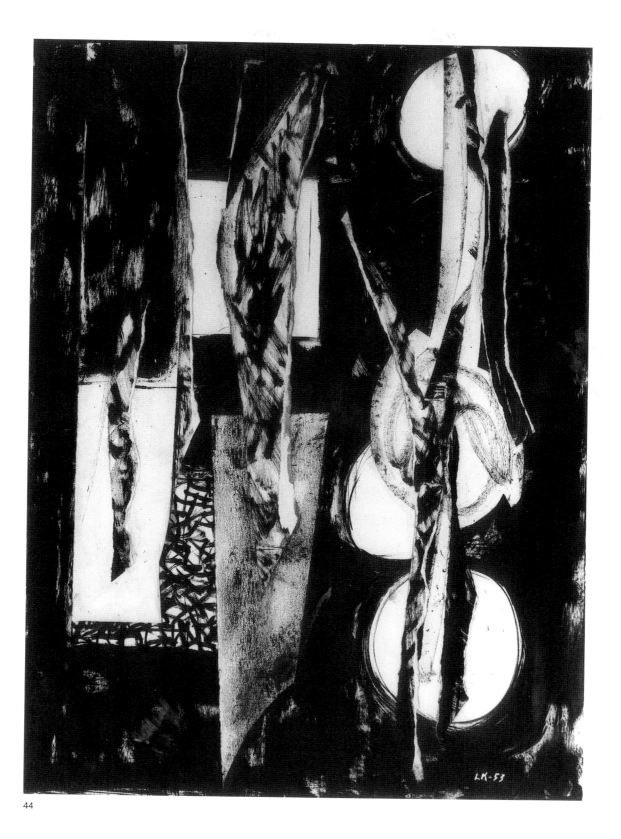

44

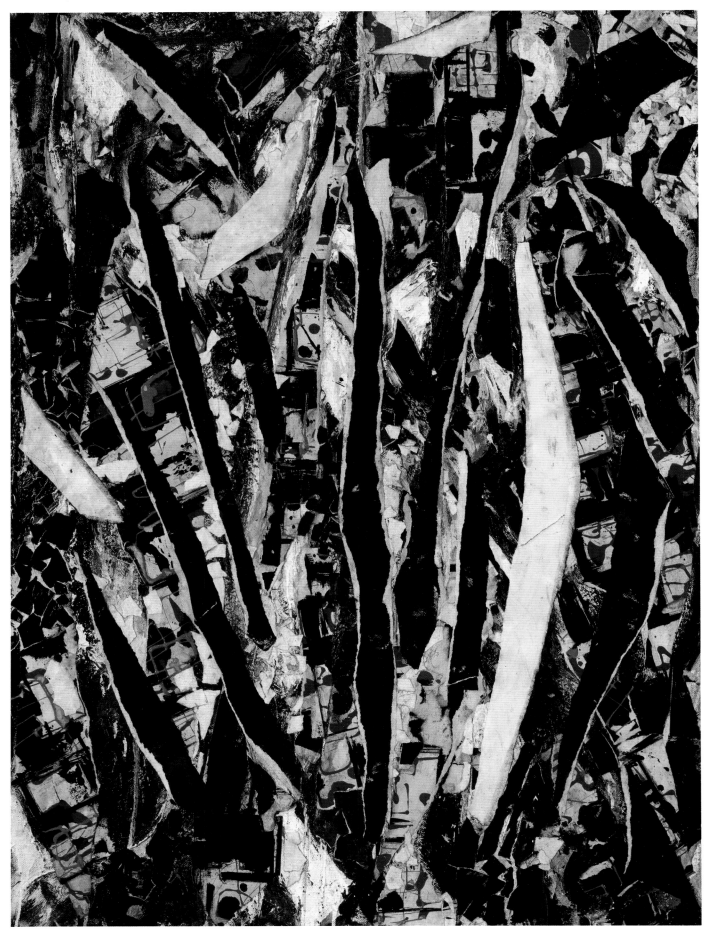

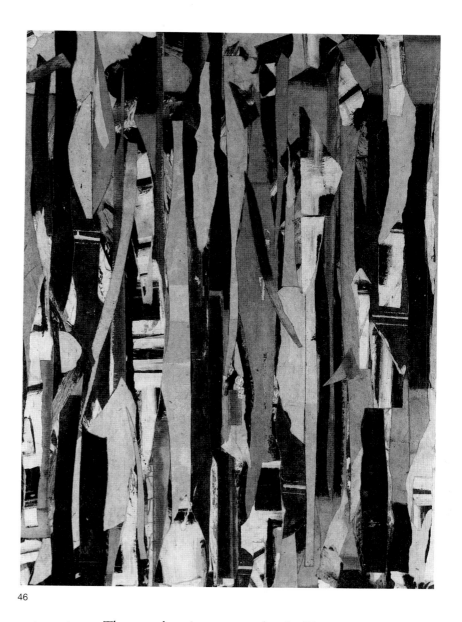

46

automatons. The overlapping rectangles in Krasner's *City* seem illogical, suggesting a toppled system of order. Black forms look like giant malignant stalks, reiterating the image of the city as an asphalt jungle, an idea current at that time and touted in a popular movie by that name. In *The City*, Krasner used the red, black, and white palette that had been favored by the Russian Constructivists and by Mondrian. Perhaps she chose that color combination to suggest the effects of unbridled utopianism and perhaps also as an allusion to Joseph McCarthy's witch hunt for "Reds," which was then ruining so many lives.[54]

The apocalyptic tone of *The City* is found also in the contemporaneous *City Verticals*, in which fractured forms imply the destructiveness of modern life and dark window shapes are submerged under detritus. The sense of outrage that permeates these urban images is tempered in Krasner's subsequent collages dealing with forests. Instead of portraying herself in front of an illusionistic forest, as in her early *Self-Portrait*, she used abstract elements to allude to tree trunks, foliage, and wildflowers. Her forest collages comprise not trees per se but fragments of her own art. In

these collages she was dealing with the idea of survival through change, and unlike the formalist disjunction of some Cubist collages, the disjunction in these forest collages is psychological.

47 *Shattered Light* is another example of Krasner's efforts to integrate her present and past. Here the collaged elements (again, remnants of her destroyed drawings) are woven into a work in which the paint itself resembles shards. *Shattered Light* may thus be interpreted as dealing with destruction. Interspersed throughout the work are egg forms, both broken and whole, which may relate to the iconography of Gorky's *Liver Is the Cock's Comb*, in which he combined allusions to eggs, feathers, and viscera as evocations of the modern soul.

The collage medium gave Krasner an opportunity to try out new, dissonant color combinations that were both striking and disconcerting. Dissonance has been an important element in the music of Charles Ives and John Cage, but its use in the visual arts has been more limited. Only late in his career did Picasso begin to investigate the power of jarring color. Krasner's research during the mid-1950s into the aesthetic potential of disharmonious color combinations—reds and oranges, browns and purples, reds and lavenders—was a relatively new area of investigation. She also heightened tension in her collages by contrasting soft and sharp focus and by obscuring the distinctions between figure and ground.

Krasner was infuriated by Harold Rosenberg's definition of Abstract Expressionism as "Action painting," probably because she thought it elevated de Kooning's work at the expense of Pollock's. (Rosenberg's concept of Action painting was the artistic counterpart of existentialism, in which the canvas was regarded as an arena and risk taking was idealized.[55]) But another reason for her intense reaction may have been Rosenberg's description of the creation of art as a battle with oneself, involving emotions but not thought. Rosenberg's privileging of feelings over intellect may have been particularly threatening to her at a time when she was attempting to come to terms with a number of her own strong emotions, including her intense resentment toward Pollock and anger at herself. In her own art Krasner had fought a number of battles, including an intense confrontation with herself—the self created in response to particular individuals and distinct circumstances. By destroying her works of the early 1950s, for example, she was waging war on that part of herself that had been influenced by Pollock and Mondrian. This act of aggression may have been caused partly by the belligerence for which she was already renowned. But it also stemmed from her growing disenchantment with Pollock and her need to engage in dialogue with other artists.

Krasner's interest in language may provide an important clue to her manner of working, since language is based on the need to name, to exchange ideas, to give voice to one's own feelings. Krasner's hieroglyphic Little Images had been extremely private communiqués to herself and Pollock; they were not exhibited publicly at the time they were being painted and were not emphasized as a group until the late 1950s. But Krasner knew that her collages made in the mid-1950s would be viewed by other New York Abstract Expressionists, and she intended them to be part of a

47

public forum. She even used her full name, instead of her usual initials, to sign *Bird Talk* and *Shooting Gold.* Her achievement was 53, 51 recognized by Greenberg, who later referred to her 1955 show at the Stable Gallery as one of the great exhibitions of the decade.[56]

Krasner's interest in dialogue was catalyzed by the type of psychotherapy that she was undergoing in 1955, in an effort to resolve some of the problems in her marriage. She was working with Dr. Leonard Siegel, an advocate of Harry Stack Sullivan's theory that an individual's personality is determined by relatively enduring patterns of personal relationships.[57] Siegel helped Krasner to free herself from the Abstract Expressionist concept of isolated, self-imposed identity and to formulate an enlarged sense of both her self and her art as syntheses of relationships with others.

The idea of artistic discourse soon became evident in her painting. In *Blue Level,* for example, Krasner took on Matisse 48 and his American follower Robert Motherwell, producing a work that offers comparison to both Matisse's Jazz series and Motherwell's Elegy to the Spanish Republic series. In *Lame Shadow* (Robert Miller Gallery, New York) she brought together the black silhouetted forms of Motherwell, the dusky colors and brutal edges of Clyfford Still, and the light-hued zips of Barnett Newman's work, suggesting how they might relate to one another. In *Image on Green (Jungle)* she took the shapes from 91 David Smith's Tank Totems and transformed them into an

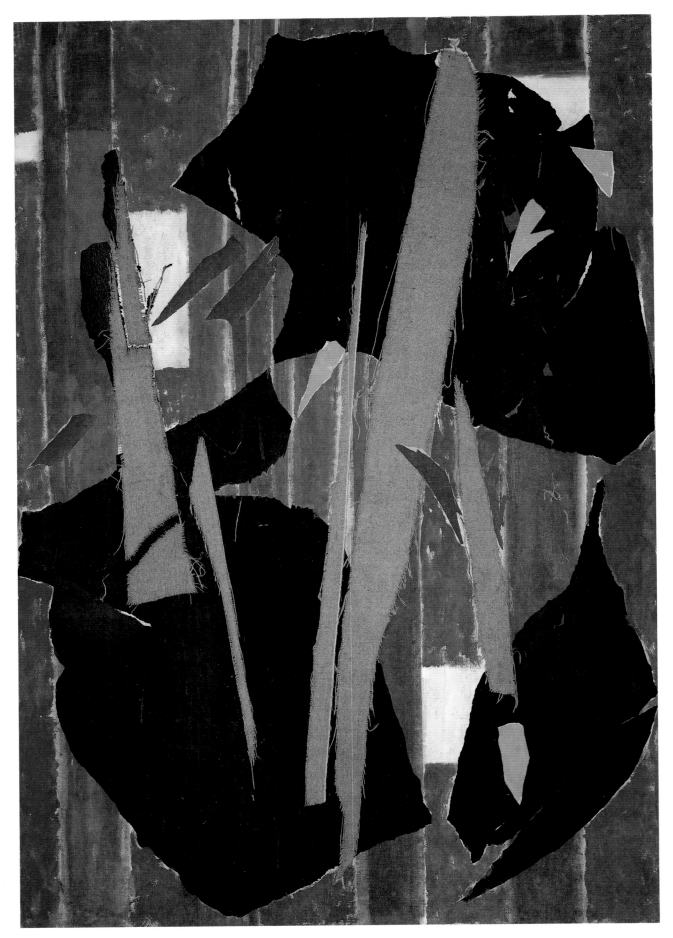

48

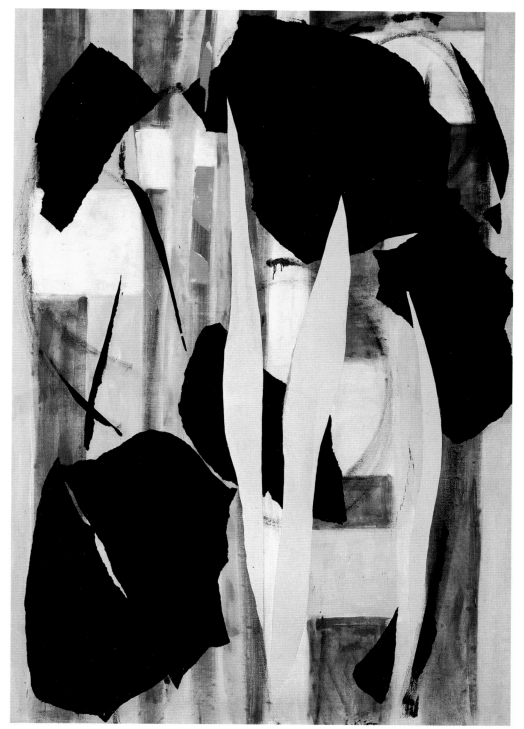

49

48. *Blue Level*, 1955
Oil and collage on canvas, 82¼ x 58 in.
(208.9 x 147.3 cm)
Robert Miller Gallery, New York

49. *Milkweed*, 1955
Oil, paper, and canvas on cotton duck,
82½ x 57¾ in. (209.5 x 146.7 cm)
Albright-Knox Art Gallery, Buffalo; Gift of
Seymour H. Knox

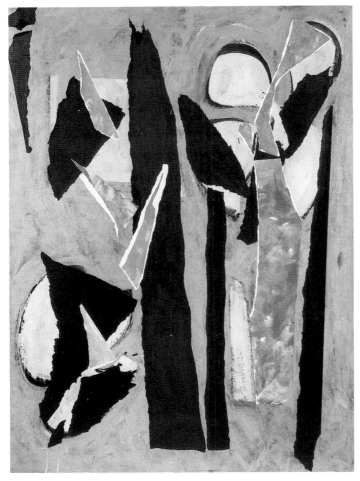

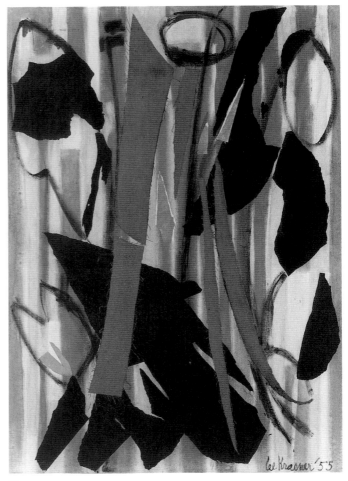

50

51

abstract painting of a plant that recalls her own AAA works. Her *Desert Moon* evokes work by a number of the other Abstract Expressionists: de Kooning in the biomorphic lavender forms, Still and Motherwell in the black passages, Rothko and Gorky in the background. In *Shooting Gold,* Motherwell's early striped paintings as well as his large paintings that depend on the collage aesthetic have been reworked as abstract floral shapes. And in *Milkweed,* Motherwell is again Krasner's main subject, with Rothko's multiforms acknowledged in the background. 50 51 49

Because Krasner reserved a special wrath as well as a deep respect for de Kooning, the dialogue that she maintained with him in her collages is particularly complex. In *Bald Eagle* she used a cut-up section of Pollock's drip paintings (and possibly referred to his aquiline profile by including an eagle at the center 52

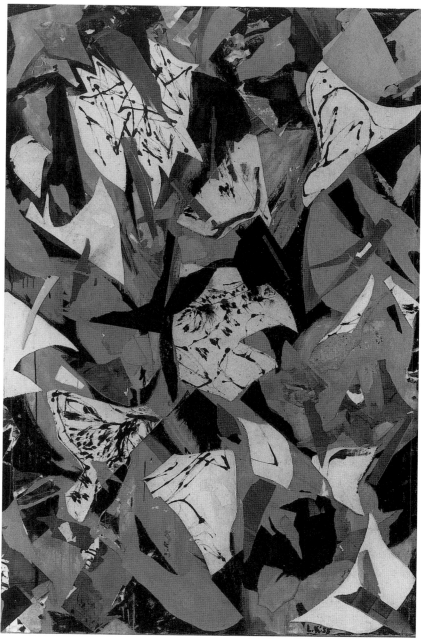

50. *Desert Moon,* 1955
Collage on canvas, 58 x 42½ in.
(147.3 x 107.9 cm)
Robert Miller Gallery, New York

51. *Shooting Gold,* 1955
Oil with paper and burlap collage on canvas,
82¼ x 58½ in. (208.9 x 148.6 cm)
Mr. Fayez Sarofim; Courtesy Robert Miller
Gallery, New York

52. *Bald Eagle,* 1955
Oil, paper, and canvas on linen, 77 x 51½ in.
(195.6 x 130.8 cm)
Audrey and Sydney Irmas; Courtesy Robert
Miller Gallery, New York

52

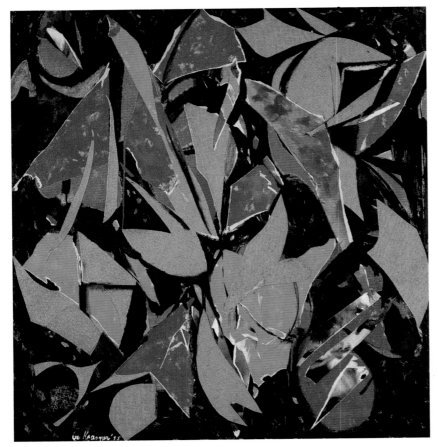

53

of the work), but the overall composition of the collage accords with de Kooning's use of overlapping, interpenetrating forms. One might say that *Bald Eagle* is a de Kooning made even more abstract. In place of the ambiguous body parts or landscape elements that de Kooning was using in this period, Krasner distributed parts of Pollock's discarded work. Her reference to de Kooning's style, her incorporation of actual pieces of Pollock's art, and the resulting ambiguity of whether the work is an homage to de Kooning or to Pollock may reflect her own indecisiveness at a time when Pollock had lost his artistic vision and de Kooning was creating some of his most important works.

53 In *Bird Talk*, de Kooning's style clearly takes precedence over Pollock's, and even though the work employs Krasner's own iconography and dissonant colors, it is more a compliment to de Kooning than a criticism. Composed of shapes resembling flying birds, beaks, and flowers, the collage alludes to the universal symbolism of birds as spiritual messengers. Sections of blurred photographs in this work underscore Krasner's interest in enigma as a significant component of her art.

The complexity of Krasner's response to de Kooning is evident in May Tabak's caustic observation: "Lee had adored de Kooning [in the late 1930s and early 1940s], thought he was the greatest painter in the world. As soon as she got hold of Jackson, she switched and would have nothing to do with him."[58] In the 1950s Krasner's early infatuation turned to rancor. According to

53. *Bird Talk,* 1955
Oil, paper, and canvas on cotton duck,
58 x 56 in. (147.3 x 142.2 cm)
Robert Miller Gallery, New York

54. *Prophecy,* 1956
Oil on cotton duck, 58⅛ x 34 in.
(147.3 x 86.3 cm)
Robert Miller Gallery, New York

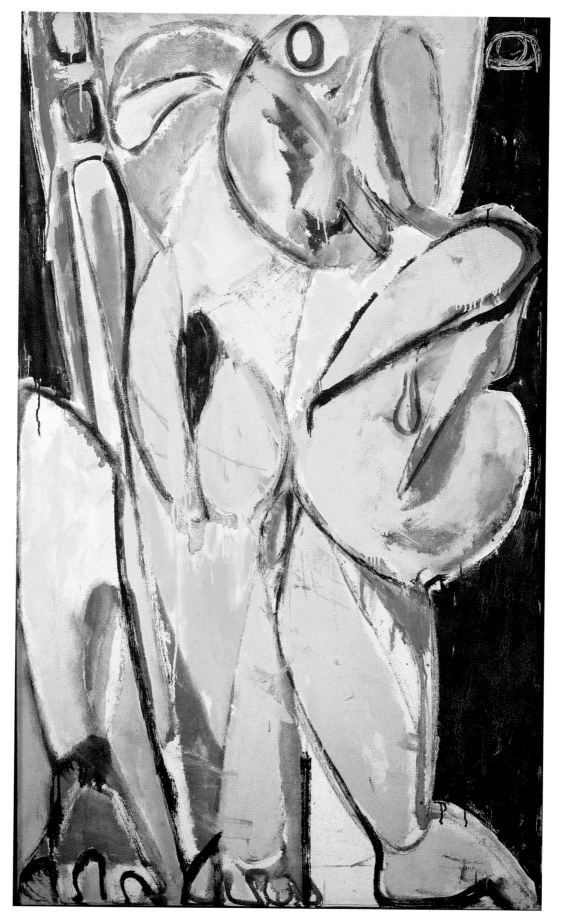

her friend Cile Downs, "Around Lee we were taught nothing but derogation of de Kooning: she knocked him all the time."[59] But de Kooning remained a force for Krasner to grapple with. She had to deal with him not only because she was attracted to his work but also because Pollock himself was intrigued with it, as his *Easter and the Totem* (1953; Museum of Modern Art, New York) clearly indicates. Her fascination with de Kooning was due in part to Pollock's esteem but even more to her own loss of faith in Pollock and her need to look elsewhere for a challenging artistic discourse.

At the time Pollock was flaunting his relationship with a young, enormously attractive woman named Ruth Kligman. Morose, unpredictable, and prone to bouts of drinking, he was seeking solace in the relationship with Kligman rather than with Krasner, and the breach in their marriage widened even more. By 1956 the Pollocks' relationship had become so difficult that Krasner decided to spend part of the summer in Europe, where she would visit museums, see old friends, and even look up Peggy Guggenheim in Venice. Before leaving, Krasner painted *Prophecy*, a figurative work that calls to mind not only de Kooning's art but also certain early Pollocks as well as Picasso's heavy nudes of 1906. The painting unnerved Krasner. "The image was there, and I had to let it come out," she later reflected. "I felt it at the time. *Prophecy* was fraught with foreboding. When I saw it, I was aware it was a frightening image."[60] The work may have been upsetting to Krasner because it was the most realistic figure she conceived using the improvisatory technique of psychic automatism. The incised eye at upper right particularly disturbed her, and Pollock suggested that she paint it out. She decided, however, to leave it.

Barbara Rose has pointed out that the figure in *Prophecy* is a merger of a male and a female and that this androgynous being might represent the then-problematic alliance between Krasner and Pollock.[61] This hybridized figure can also be interpreted as Krasner's own self in the process of transformation. It has three legs, two female torsos, and a number of heads, two of which are clearly discernible. To the left of the figure is a diagonal form that resembles one of Louise Bourgeois's totems with breasts. The figure can also be read as an image of the self becoming aware of its shadowy background, which is made anthropomorphic by the inclusion of the schematic eye in the upper-right corner.

Krasner left *Prophecy* on her easel when she departed for Europe on July 12. Her trip was soon cut short by a call from Clement Greenberg, who told her that Pollock had been killed on August 11 in an automobile accident. One of the women in the car, which Pollock had been driving, was killed; the other, Ruth Kligman (who had moved into the Pollocks' house after Krasner's departure), was badly hurt. After the accident Kligman moved in with de Kooning, thus making Krasner even more infuriated and obsessed with him in her art.[62]

When she returned to the United States, Krasner had to confront not only Pollock's death, his continual unfaithfulness to her, and her new duties as his executrix and sole heir, but also her own guilt about having abandoned him. The analysis she had

54

55. *Birth*, 1956
Oil on cotton duck, 82½ x 48 in.
(209.6 x 121.9 cm)
Barbara B. Millhouse

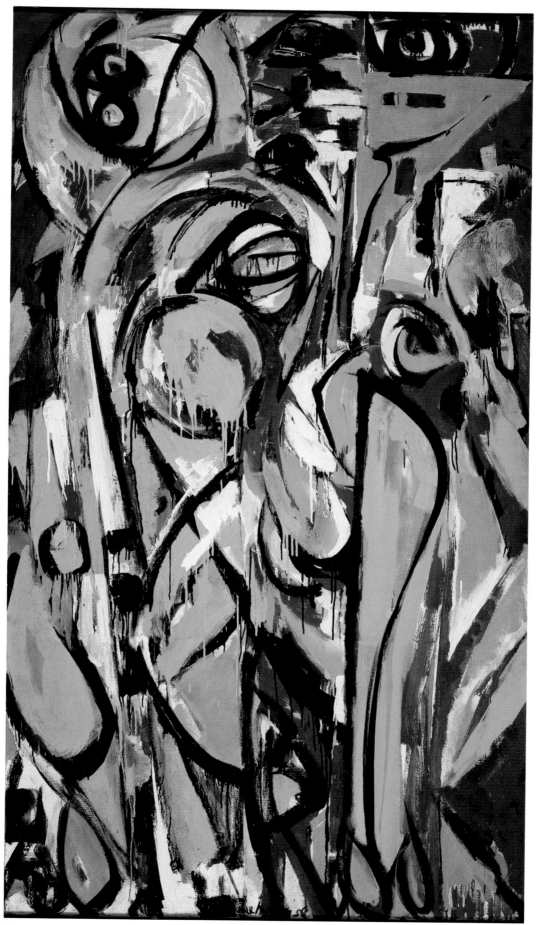

55

undergone before Pollock's death helped her adjust to his loss (at least in aesthetic terms) by enabling her to put him in perspective as just one among a number of important Abstract Expressionists. In her business dealings she became known as the artist's formidable widow. But in her art she reveals the far more interesting story of her fight for emotional survival by learning to provide nurturance through her art rather than through her destructive relationships with Pollock and Pantuhoff.

Following Pollock's death, Krasner's first major task as an artist was to deal with the terror that *Prophecy* evoked in her. "I had to confront myself with this painting before I was able to start work again," she reflected. "I went through a rough period in that confrontation."[63] In the Earth Green series of seventeen works created during the eighteen months immediately after Pollock's death, Krasner experienced the difficulty and exhilaration of creation, the fears of being subsumed in mythic content, and the satisfaction of finally developing and accepting an enlarged sense of self as a result of her deep commitment to fulfilling her own nature. In these paintings Krasner was going against the grain of Abstract Expressionism by creating figurative images at a time when other artists in the group (though not de Kooning) were becoming resolutely abstract. As she later expressed it, "No one was more surprised than I was when the breasts appeared."[64]

Among the first paintings that Krasner made after Pollock's death is *Birth*. He had used that title for one of his early paintings (c. 1938–41; Tate Gallery, London), which conflated anatomical forms, Eskimo masks, and generalized primitive references. In contrast, Krasner took her inspiration directly from two masters of the modern tradition, de Kooning and Picasso. Her whiplash lines and ambiguous body parts, representing buttocks and/or breasts, are derived from de Kooning; the eyes and the turning head with upraised arms at upper left resemble a standing figure in Picasso's well-known *Demoiselles d'Avignon* (Museum of Modern Art, New York). *Birth* is a landscape of bodies: large, pendulous breasts and swelling shapes are indicative of pregnancy, but in a negative context, for the forms are dismembered and strewn across the canvas. Although there appears to be more than one figure, it is difficult to say if Krasner intended this to be one female in different guises, several different figures, or perhaps even a symbol of the radical violence done to the self in the modern world. Whatever her intent, the work associates birth with violence and with the breakup of something that had once been complete and whole. In their abstractness the figures also call to mind Krasner's early studies of models at Hofmann's school. But whereas the fragmentation of the figure in Hofmann's classes was regarded as a natural process of abstraction, in *Birth* and in the related painting *Three in Two* (Mr. and Mrs. Robert I. MacDonnell, San Francisco), abstraction is seen as a brutal and unnatural act.

Birth expands on the theme, nascent in *Prophecy*, of the self's transformation and the ritualistic destruction of the old order needed to make way for the new. In this sense *Birth* is a reenact-

ment of the Dionysian mysteries: Dionysius, the dismembered Greek god who was planted in the soil, is replaced here by a sacrificed female who is left bleeding. The sacrificial female appears to be the subject of *Listen,* one of the first paintings in Krasner's p. 2 Earth Green series. She experienced great anguish while creating it: "When I was painting *Listen* which . . . looks like such a happy painting . . . I almost didn't see it, because tears were literally pouring down."[65]

Krasner's assessment of *Listen* as appearing "happy" does not do it justice. It features a plant that bears fruit in the form of huge breasts and a deep red background that can be seen as the blood of dismemberment, and perhaps also the blood that nurtures and sustains life. *Listen* deals with growth and fruition but also with the pain of transformation and the loss of the old self.[66] Even though the subject is clearly Krasner's own, this work is indebted to the strange voluptuousness and the layered body parts of Gorky's late work. Some critics have viewed Krasner's sprawling calligraphic signature as a way of disguising her identity, but in *Listen* it appears to manifest a deeper sense of self, since the sepia used for the signature is also employed for the breastlike fruits and for the vase that holds the plant.

The same year that Krasner painted *Listen* she was creating a number of works in the Earth Green series that are devoted to fecundity, growth, and harvest. *Sun Woman I* announces a new 2 unity and harmony: it still comprises an assortment of selves, but they appear unified and in the process of growth. The major elements in the painting are egg-shaped figures with budlike breasts and blossom heads, as well as green shoots in the upper left that represent new life. This image of a solar-and-earth deity has crudely drawn hands that trail off into the artist's signature on the right. In some of her collages Krasner had suggested light by leaving the canvas empty; here the background is saturated with light in the form of white paint lightly scumbled in places with yellow, pink, and green. This new emphasis on light is one of the reasons for the title; the other is the optimism occasioned by new growth, which the painting celebrates.

At first glance *Sun Woman II* does not seem related to *Sun* 3 *Woman I.* Closer inspection reveals that the sun-and-earth goddess appears here as well, but she has become more abstract and situational and less a separate personage. Since the forms on the right resemble fetuses, one might even hypothesize that she has become part of the germination of life. Whereas the red in *Birth* and *Listen* seems to flow from wounds, in this picture the red seems to be a source of life to the green that surrounds it and appears to draw sustenance from it.

The ebullient harmony of the life-force that pervades *Sun Woman I* and *II* is intensified in *The Seasons,* with its sweeping 56 rhythms and undulating curves that join aspects of the human realm with the plant kingdom to suggest the cycles of germination, growth, and fruition. There are leaf forms that resemble parts of plants and buds that burst with new life; other forms look like human arms and hands, an abstracted torso, and male genitalia. In *The Seasons,* as in other works of this fertile period,

PAGES 68–69

56. *The Seasons,* 1957
Oil on canvas, 92⅞ x 203¾ in.
(235.5 x 517.5 cm)
Whitney Museum of American Art, New York;
Purchase, with funds from Francis and Sidney
Lewis (by exchange), Mrs. Percy Uris
Purchase Fund and the Painting and
Sculpture Committee

57. *Celebration,* 1959–60
Oil on canvas, 92¼ x 184½ in.
(234.3 x 468.6 cm)
Private collection; Courtesy Robert Miller
Gallery, New York

58. *Cornucopia,* 1958
Oil on canvas, 90½ x 70 in. (229.9 x 177.8 cm)
Gordon F. Hampton, Los Angeles; Courtesy
Robert Miller Gallery, New York

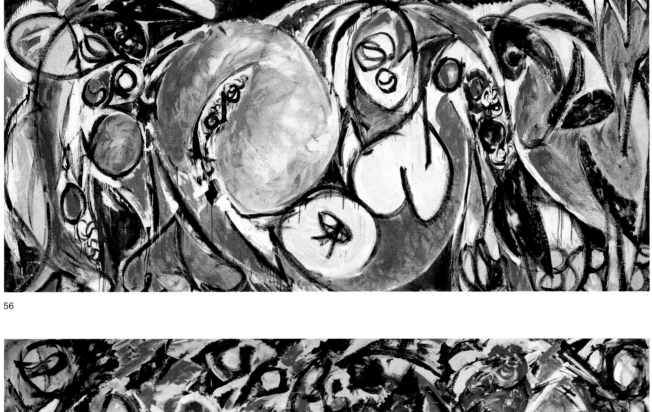

56

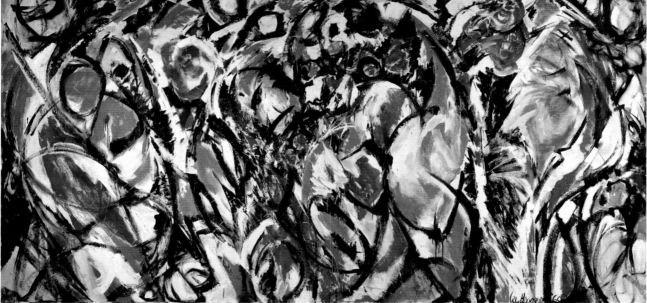

57

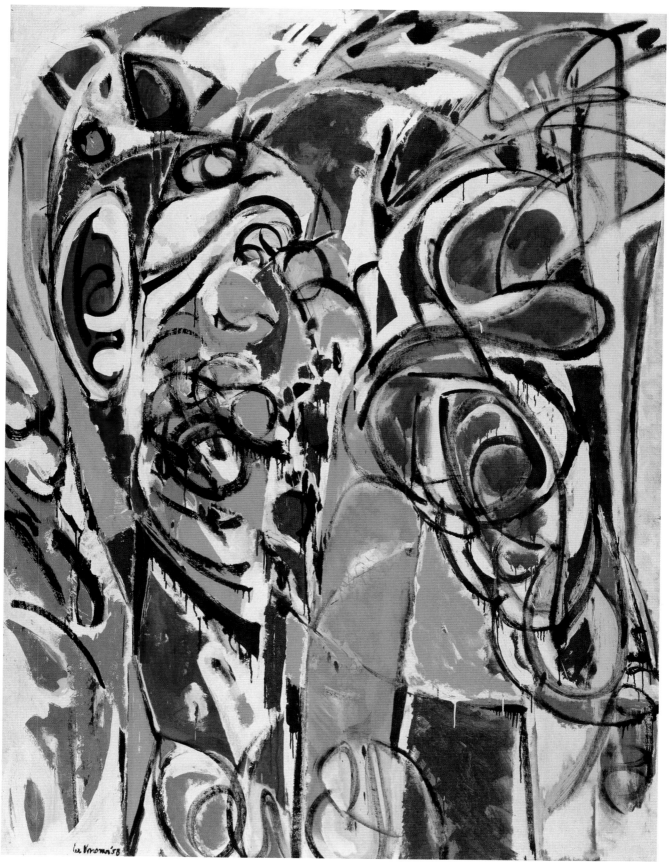

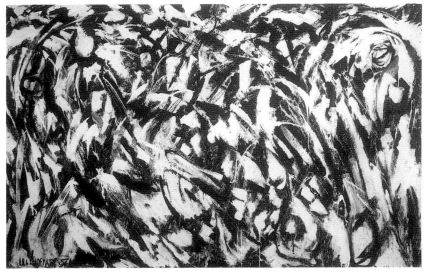

59

Krasner created hybrids that were intended to be living forms in a state of metamorphosis. In case one missed the point in *The Seasons*, both the title and the abstracted forms of *Cornucopia* make it abundantly clear that Krasner's internal nature is reaping a bountiful harvest. This is a celebratory painting with forms so abundant that they tumble out in exuberant spirals, exhibiting great energy and force.

In 1959 the temper of Krasner's art changed. She wistfully eulogized this change in the transitional *Spring Memory*, which presents partially buried signs in conjunction with red paint possibly signifying blood. Although she titled one of her major pieces from 1959–60 *Celebration*, it was a pivotal work, continuing the ebullience of *Sun Woman II* and anticipating the Umber series (1959–62; also known as the Night Journeys), which constituted a descent into chaos. Along with *The Gate, Celebration* was Krasner's last big painting to employ color before the Umber series. In *Celebration* she threw her ropy black lines like a lasso, catching elements of figures in a tangled web. Although the work contains brilliant passages and a wonderful sense of energy, it is not as resolved as the paintings made before and after it.

In the years immediately following Pollock's death, Krasner's art underwent a dramatic change that may have had as much to do with her year of therapy as with the relief she must have felt in no longer having to shoulder Pollock's emotional burdens. Although she experienced a long period of grief after his death and certainly mourned his loss, her art expresses a joy in being able to focus on herself and her own growth. After the highly successful Earth Green series, Krasner's art took a decided turn. She had gained the strength to tackle Pollock once again and to wage war on his drip paintings (which were then regarded as chaotic and forceful, as opposed to the highly energized, carefully resolved compositions they are now considered to be). Her change in style was considered both abrupt and reactionary. Having been impressed by her Earth Green series, Greenberg had offered Krasner a show at French and Co. When he reacted negatively to the Umber series—which many people regarded as

59. *The Gate*, 1959–60
Oil on canvas, 91⅞ x 145½ in.
(233.4 x 369.6 cm)
Private collection; Courtesy Robert Miller Gallery, New York

merely reworkings of Pollock's art—she canceled the show to pursue her new work.

Krasner's recapitulations of Pollock's drip paintings in the Umber series may have been occasioned by her mounting responsibilities as sole heir and executrix of the large and increasingly valuable Pollock estate. Beginning in 1956 and continuing until her death, she not only became the arbiter of which works by Pollock would be lent to exhibitions but she also became known as a major source regarding his past and his intentions. She treated these duties seriously and allowed them to take precedence over her own travel and at times her own work, but she must have been distressed by the great interest expressed by critics, historians, and dealers in Pollock's art as opposed to their lack of interest in her own. The one benefit of these troublesome responsibilities was the money they provided for her to hire studio assistants and to buy the New York apartment she used as both living space and studio.

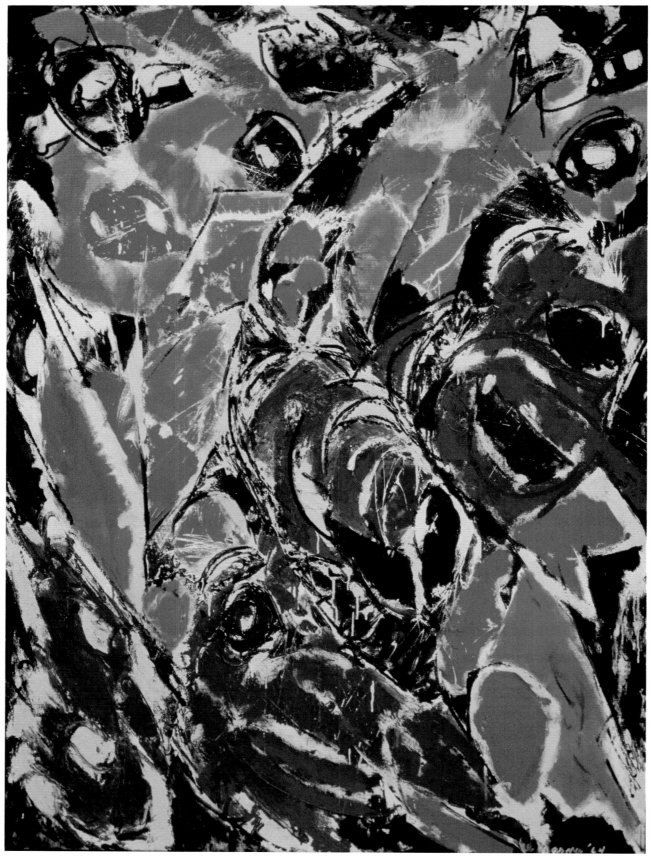

Change Is the Only Constant

Krasner once described change as perpetually forced upon her:

My own image of my work is that I no sooner settle into something than a break occurs. These breaks are always painful and depressing but despite them I see that there's a consistency that holds out, but is hard to define. All my work keeps going like a pendulum; it seems to swing back to something I was involved with earlier, or it moves between horizontality and verticality, circularity, or a composite of them. For me, I suppose that change is the only constant.[67]

In 1959, when her art began to move in a new direction after an intensely creative period, Krasner had no other choice but to follow it. She later recollected parts of the process in an extended interview with her friend the poet Richard Howard, who together with another literary friend helped her give titles to the paintings in the Umber series.[68] In the interview both Krasner and Howard refer to the paintings as "Night Journeys." According to them, *The Eye Is the First Circle* (1960) is one of the first paintings in the series. Almost sixteen feet long, it was made in East Hampton before Krasner moved to Manhattan and at a time when she was beginning to suffer insomnia and to paint at night. But it was made concurrently with *The Gate* (1959–60), which according to Krasner, was "very much connected with my mother's death, at least on a conscious level."[69] Her mother's death, Pollock's death, and the cancellation of her show at French and Co. plunged her into a deep depression that became a catalyst for the Night Journeys. Her decision to limit her palette to blacks, whites, ochers, and browns seems to have been made primarily for emotional reasons and only secondarily because she was painting at night and did not want to risk having the balance of her colors upset by artificial light. She may also have found that color detracted from the intense emotions conveyed through her welters of brush strokes and flecked paint.

The phrase "The Eye Is the First Circle" came to Krasner after the painting was done, because only then did she see the eyes in

61

59

60. *Bird's Parasol*, 1964
Oil on canvas, 61 x 46⅛ in. (154.9 x 117.1 cm)
Meredith Long & Company, Houston;
Courtesy Robert Miller Gallery, New York

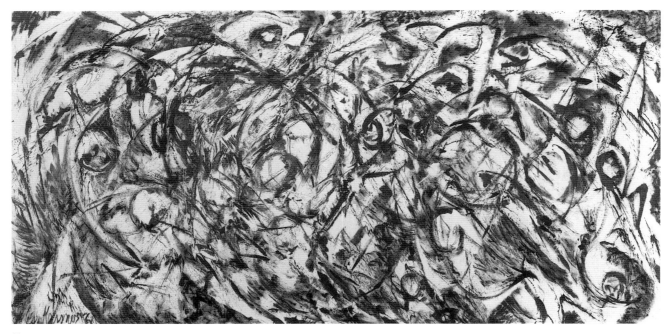

61

it.[70] She thought the title was her own invention, and only later did she discover that it was the first line of Emerson's essay "Circles," which she had read many years before, along with his other essays. Emerson's transcendentalism is relevant not only to this painting but also to Krasner's manner of working, for he believed in shattering the old to make room for the new. In "Circles" he enunciates the need to break out of old molds and to establish an enlarged sense of self: "The one thing which we seek with insatiable desire, is to forget ourselves, to be surprised out of our piety, to lose our sempiternal memory, and to do something without knowing how or why; in short, to draw a new circle."[71] Emerson came to the conclusion that all life is dynamic and that a static self is out of kilter with the rest of the universe.

While *The Eye Is the First Circle* heralds Krasner's need for regeneration, *The Gate* establishes the theme of the Night Journeys as the exploration of the little-understood threshold between the conscious and unconscious mind. And the painting *Polar Stampede* evokes the chilling onrush of feelings with which Krasner was coping. Night Journeys with such titles as *Entrance*, *The Guardian*, *Vigil* (which Krasner referred to as "being on guard at every moment while one is descending"[72]), *Messenger*, and *Uncaged* all refer to this state of liminality. Other titles of works in the series— such as *Charred Landscape*, *Primeval Resurgence*, *Seeded*, and *Cosmic Fragments*—deal with destruction and rebirth.

Painted thinly but with a furious rush of brushwork that blocks many of the figurative elements (*Triple Goddess* being an important exception), the Night Journeys are notable for their large scale, their strokes furred with sprays and spatters, and their emotional intensity. According to Howard, people talked about how Krasner was "being influenced by Jackson from beyond the grave."[73] Although such remarks may have taken irrational form, they are accurate in acknowledging Krasner's

61. *The Eye Is the First Circle*, 1960
Oil on canvas, 92¾ x 191⅞ in.
(235.5 x 487.3 cm)
Robert Miller Gallery, New York

62. *The Guardian*, 1960
Oil on canvas, 53 x 58 in. (134.6 x 147.3 cm)
Whitney Museum of American Art;
Purchase, with funds from the Uris Brothers
Foundation, Inc.

dialogue with Pollock and with the concept of chaos. For several of the Abstract Expressionists, chaos meant the often frightening situation of breaking up the old self in order to make way for the new. Krasner indicated to Howard that she "was going down deep into something which wasn't easy or pleasant."[74] Such feelings are embodied in the maelstrom of her brushwork, which captured a sense of surging movement and untempered force.

When figurative elements do appear in a Night Journey, as in *Triple Goddess*, they are caught in a tangle of paint. Held hostage by ropy lines as well as by spatters of paint, the Triple Goddess is engulfed by chaos. In this painting Krasner played with eye shapes that are blank and thus perhaps blind. Her *Triple Goddess* can be read as a new interpretation of the three Fates, who usually were pictured as calmly spinning, measuring, and cutting the thread of each individual's life; Krasner's *Triple Goddess*, however, is entangled rather than in command.

Krasner sustained the intensity of her Night Journeys for almost three years, and then she stopped abruptly because of a serious aneurysm. It was successfully treated, but during this same period she fell and broke her wrist, which meant that she had to begin painting with her left hand. The ensuing works have none of the force of the Night Journeys. Delicate, small, and impressionistic, they are a needed respite after a major undertaking. *The Springs*, 99 for example, is lyrical and filled with light—a rococo fantasy as compared to the baroque mysteries of the Night Journeys.

Beginning in 1964 Krasner created works in response to current vanguard styles. With her usual toughness, she began to look, to critique, and most important to create viable alterna-

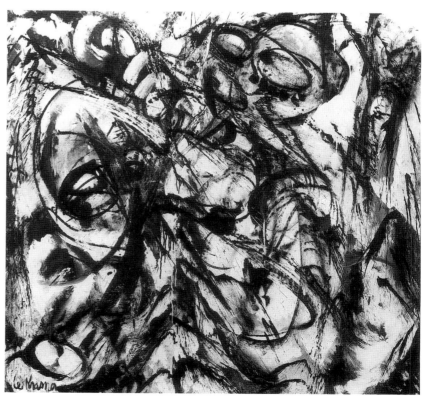

62

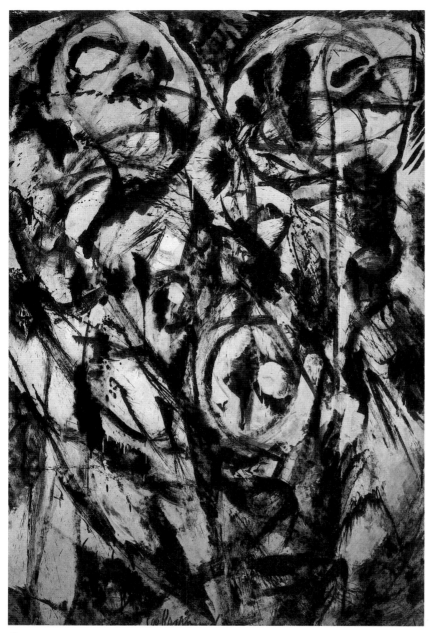

63

tives. During the 1950s she had been too caught up with the traumatic changes in her life and too involved in a dialogue with the first generation of Abstract Expressionists to study the work of the second generation—including Grace Hartigan and Joan Mitchell. But in 1964 she acknowledged in *Bird's Parasol* the second generation's interest in landscapes rather than metaphorical "inscapes." Uninterested in mythic content, members of the second generation favored lighthearted colors and the beauties of landscape, which they abstracted and reduced to a few essentials. In *Bird's Parasol,* Krasner continued her interest in metaphors of rebirth and inner vision, which she manifests through the eye, egg, and bud forms that are liberally distributed throughout the canvas. But she also delighted in painting the bright pink-and-orange plumage, olive green foliage, and deep blue background to suggest a tropical environment. She also referred to the hedo-

60

63. *Triple Goddess,* 1960
Oil on canvas, 86 x 58 in. (218.4 x 147.3 cm)
The Estate of Lee Krasner; Courtesy Robert Miller Gallery, New York

64. *Polar Stampede,* 1960
Oil on canavs, 93⅝ x 159¾ in.
(237.7 x 405.7 cm)
The Estate of Lee Krasner; Courtesy Robert Miller Gallery, New York

65. *Icarus,* 1964
Oil on canvas, 46 x 69 in. (116.8 x 175.2 cm)
The Estate of Lee Krasner; Courtesy Robert Miller Gallery, New York

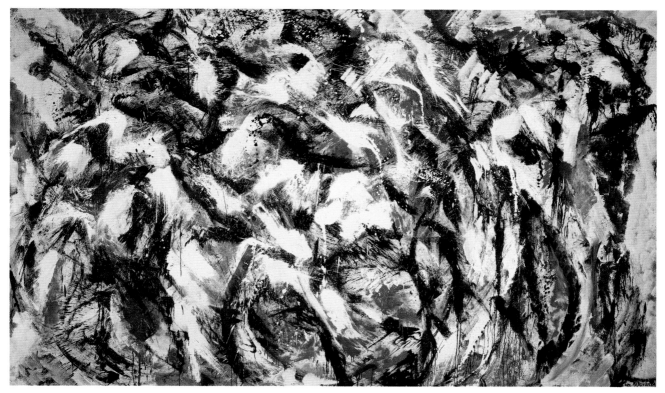

64

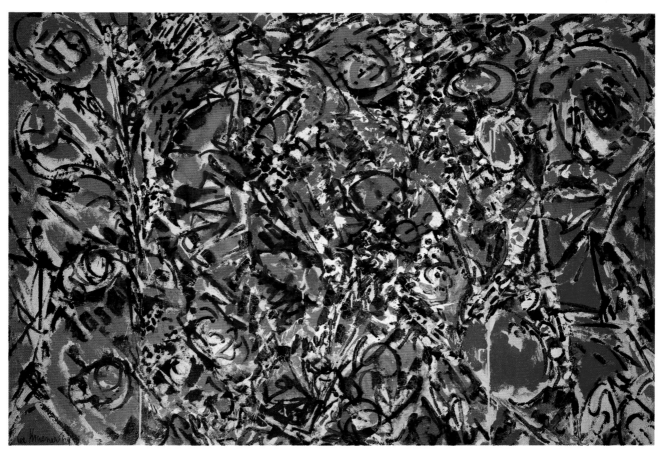

65

nistic landscapes favored by some members of the second generation in *Right Bird Left* (David T. Owsley) of the following year.

In the mid-1960s Krasner moved in many different directions at the same time. In *Icarus* she initiated a dialogue with the color-field painters espoused by Greenberg, including Morris Louis and Kenneth Noland. An important aspect of color-field painting was the importance of the work's surface, which was only lightly stained so the unprimed canvas would visually resonate. Named after the Greek mythological figure who flew so close to the sun that his wings melted, *Icarus* alludes to the tragic descent that befalls unbridled flights of ego. It is a telling title for an artist who maintained artistic identity as a series of ongoing relationships rather than solitary flights. She painted *Icarus* with a hot palette, making little distinction between figure and field. The work is notable for the aerated effect of the white background, which peers through tightly congested and fragmented forms.

Although critics and historians have pointed to *Kufic* as an example of Krasner's interest in hieroglyphic languages, they have noted neither its emphasis on eye and egg forms nor its delicate tracery of outlines, which emphasizes the thinly painted background. In *Kufic,* Krasner used two forms of communication: one is her special sign language and the other is the canvas itself, which looks old and worn in contrast with the pristine surfaces of the color-field paintings. Her discourse with color-field painting continued in *Green Rhythm (Katydid)* and *Courtship*. In both works she created a subtle interplay between figure and field. In the former she cast a number of overlapping lines to

66

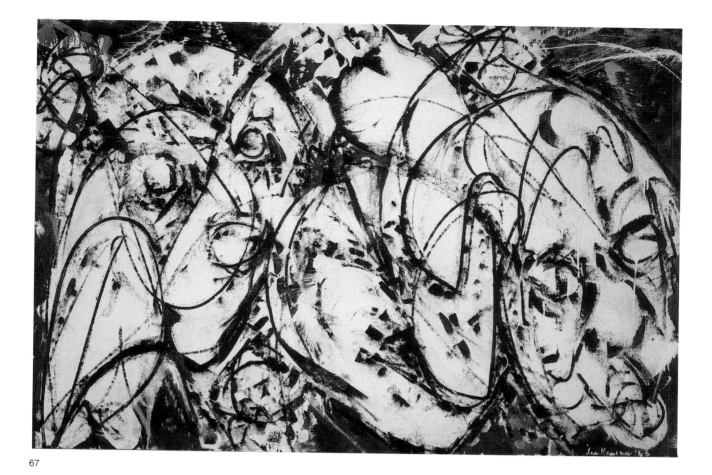

67

create a delicate web from which five (and possibly six) faces emerge. The faces relate to Pollock's black-and-white figurative works of the early 1950s and also to Cubism. The delicacy of the faces and the visual importance of the neutral ground at the work's center both acknowledge the innovations of color-field painting; their allusion to Pollock underscores his influence on the entire group. In *Courtship* two winged figures in the center are formed of unprimed canvas—such wedding of figure and field was one of the aspirations of color-field painting.

In the mid-1960s Krasner recapitulated her own history in a number of works. "I am never free of the past," she stated. "I believe in continuity. I have made that crystal clear that the past is part of the present which becomes part of the future."[75] In *Combat*, for example, she joined aspects of *The Seasons* with the chaos of her Night Journeys to create a great bacchanalian revel. Like *The Seasons*, *Combat* contains swelling pods and buds, but it presents germination as a great battle among surging and insistent abstract forms. The intense fuchsias and oranges heighten the conflict, and the white canvas is no mere background but instead is an active participant.

Gaea also merges elements from two different periods in one work, but here it is the pangs of *Birth* and the chaos of the Night Journeys. *Gaea*, a mythological character representing Earth, may be signified by the weeping head in profile to the left of center. This head belongs to a grand tradition of female mourners that includes the woman holding a torch in Picasso's *Guernica*

69, 56

71

55

66. *Kufic*, 1965
Oil on canvas, 81 x 128 in. (205.7 x 325.1 cm)
The Estate of Lee Krasner; Courtesy Robert Miller Gallery, New York

67. *Green Rhythm (Katydid)*, 1966
Oil on canvas, 43 x 65 in. (109.2 x 165.1 cm)
The Estate of Lee Krasner; Courtesy Robert Miller Gallery, New York

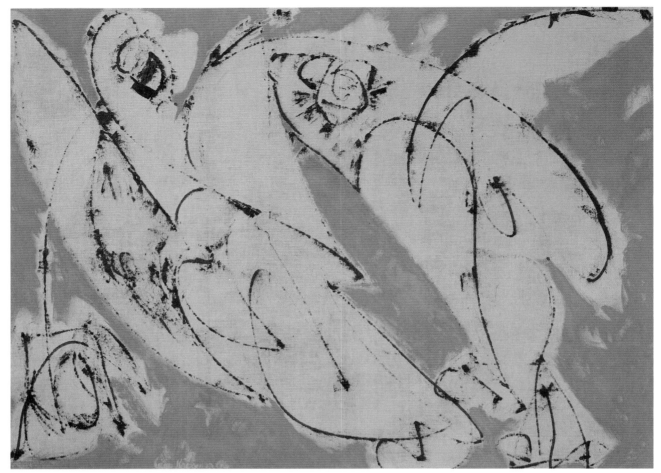

68

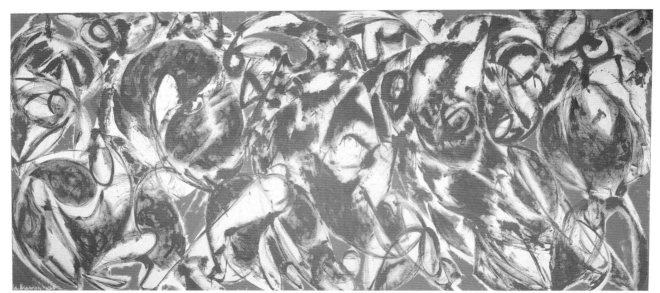

69

68. *Courtship,* 1966
Oil on canvas, 51 x 71 in. (129.5 x 180.3 cm)
Private collection, New York; Courtesy Robert
Miller Gallery, New York

69. *Combat,* 1965
Oil on canvas, 70½ x 161 in. (179.1 x 408.9 cm)
National Gallery of Victoria, Melbourne,
Australia

70. Jackson Pollock (1912–1956)
Echo (Number 25, 1951), 1951
Enamel on unprimed canvas, 91⅞ x 86 in.
(233.4 x 218.4 cm)
The Museum of Modern Art, New York;
Acquired through the Lillie P. Bliss Bequest
and the Mr. and Mrs. David Rockefeller Fund

71. *Gaea,* 1966
Oil on canvas, 69 x 125½ in. (175.2 x 318.7 cm)
The Museum of Modern Art, New York; Kay
Sage Tanguy Fund

70

71

81

70 and the profile in Pollock's *Echo (Number 25, 1951)*. In the lower center of Krasner's painting is a great trembling egg, which may be the object of concern to the weeping head. From both de Kooning and Philip Guston, Krasner learned the power of relying on traditionally sweet colors to heighten a sense of tragedy and violence. In this painting she used an unsettling color scheme of pinks, purples, and flesh tones; a touch of the complementary color, green, would have relieved the visual tension and suggested new life, but it is absent from the painting.

86 Just as tragedies need comic relief, so Krasner's intensity also required periods of respite during which she would create radiant works using hedonistic brushwork and lush colors. Such a work is *Uncial*. Its title refers to a type of Greek or Latin manuscript from 300 to 700 A.D. in which a special script of large, rounded, separated letters was mixed with cursive forms. The yellow shapes at the bottom, which look like a mirrored reversal of Krasner's name and are allied through color with her actual signature, appear to be an abstraction of uncial script. In addition to being a momentary release from Krasner's ongoing critique of various avant-garde styles (including her own), *Uncial* is among the first canvases in which she juxtaposed quasi-hard-edge and organic elements. Instead of attempting to synthesize the two, as she had in other works, in *Uncial* she kept them separate yet interactive, achieving a dissonance of forms parallel to the dissonance of colors that she had long ago mastered.

73 Heightened tensions appear in Krasner's works of 1968 in which quasi-hard-edge surfaces are joined with organic drips and spattered paint. In *Pollination* she continued the theme of the abrupt force necessary for new life by juxtaposing vertical thrusts set at a diagonal, which give the work only a tentative balance, with smeared, brushed, and stained red shapes. Along the periphery are refreshing and seemingly unpremeditated green passages. These interact with the white field, which drips and spatters as defiantly as the green areas, while the calmer and more reflective gold appears to be an abstract harvest resulting

74 from the violent insemination at the center of the work. *The Green Fuse* again contrasts hard-edge shapes with spontaneous brushwork, suggesting an inherent contradiction between imposed order and intuition. At the center of the work is the same trembling egg shape that occurs in many Krasner paint-

71 ings—most notably *Gaea*. The theme of the work appears to be the pyrotechnics that occur when willed order and power come in conflict with the life-force—perhaps *The Green Fuse* of the title.

75 In *Transition* she contrasted the themes of a superimposed order and an erupting fury. Although Krasner worked with the then high-fashion color combinations of purple and orange, she personalized the hues by modulating the purple to almost a blood red and toning down the bright orange. The reddish purple shapes in the painting look like giant calligraphy written in blood, the blue-and-white egg forms resemble abstracted planets, and the entire painting sublimates into abstract form the tensions and aspirations of that intense era.

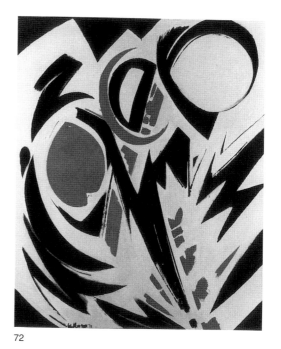

72

Krasner's art from the late 1960s—and particularly from 1968, when the war in Southeast Asia was escalating, students in Europe and America were becoming a major force, racial violence was erupting in many cities, and outer space was being explored— reflects contemporary tensions and aspirations, even though it maintains an aesthetic distance. She continued to develop the theme of human potential for change, portraying it in terms of birth images and in hybrids of humans, animals, and plants. The political situation seemed to make her message even more important, and her urgency is evident in her newly intensified contrasts of form and color, as well as in the large scale that she had favored since the late 1950s. Like many of the other Abstract Expressionists, she worked large in order to surround viewers with her works and thus directly involve them in her subject matter, which she pushed uncomfortably close to the picture plane.

After 1968 Krasner continued to work with some of the same themes, but her interests became increasingly formal. It was as if the subject matter of her art was so familiar that she no longer needed to worry about it. In *Comet*, for example, whose title 76 alludes to the exploration of outer space and abstractly pictures the breakup of an old order, she presents painting itself as a language. And her work is concerned with what occurs when one language or system of logic butts into another. Her two primary languages, as in the works of 1968, are the rational and orderly vocabulary of hard-edge painting and the improvisational idiom of drips, spatters, and loosely brushed paint.

In the early 1970s Krasner started a discourse with such hard-edge painters as Frank Stella and Larry Zox, and she also renewed a relationship with her own AAA works. She expunged all spontaneity from her work and changed the tempo of her paintings so that sweeping rhythms predominate and staccato movements are contained within overarching patterns that express her interest in deliberation and distillation. The title *Meteor* makes 72

72. *Meteor*, 1971
Oil on canvas, 81¼ x 66¼ in. (206.4 x 168.3 cm)
The Estate of Lee Krasner; Courtesy Robert
Miller Gallery, New York

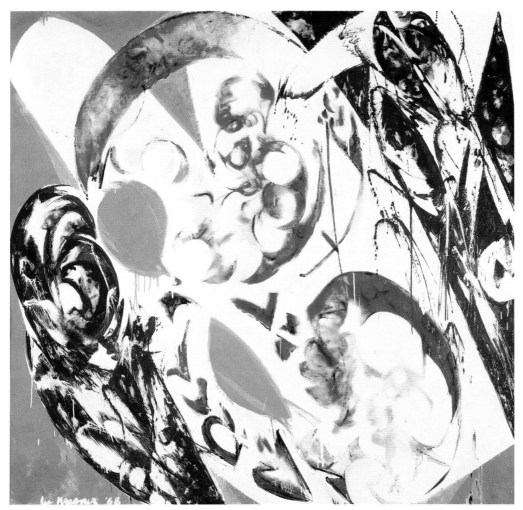

73

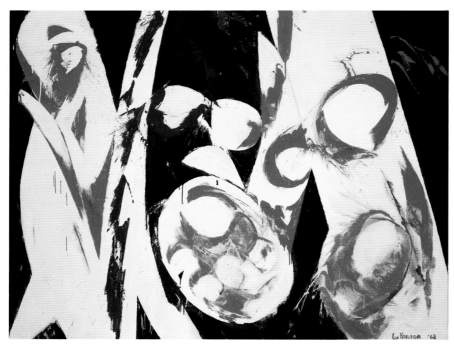

74

73. *Pollination,* 1968
Oil on canvas, 81¼ x 83 in. (206.3 x 210.8 cm)
Dallas Museum of Art; Gift of Mr. and Mrs.
Algur H. Meadows and the Meadows
Foundation Incorporated

74. *The Green Fuse,* 1968
Oil on canvas, 68 x 90 in. (172.8 x 228.7 cm)
Mr. Fayez Sarofim; Courtesy Robert Miller
Gallery, New York

75. *Transition,* 1968
Oil on canvas, 68 x 100 in. (172.7 x 254 cm)
Mr. and Mrs. Meredith J. Long; Courtesy
Robert Miller Gallery, New York

76. *Comet,* 1970
Oil on canvas, 70 x 86 in. (177.8 x 218.4 cm)
The Estate of Lee Krasner; Courtesy Robert
Miller Gallery, New York

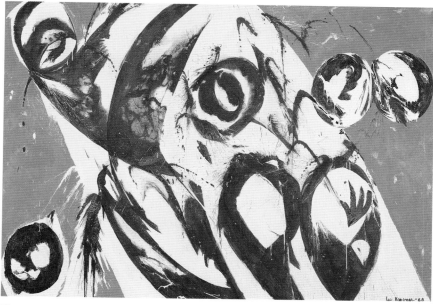

75

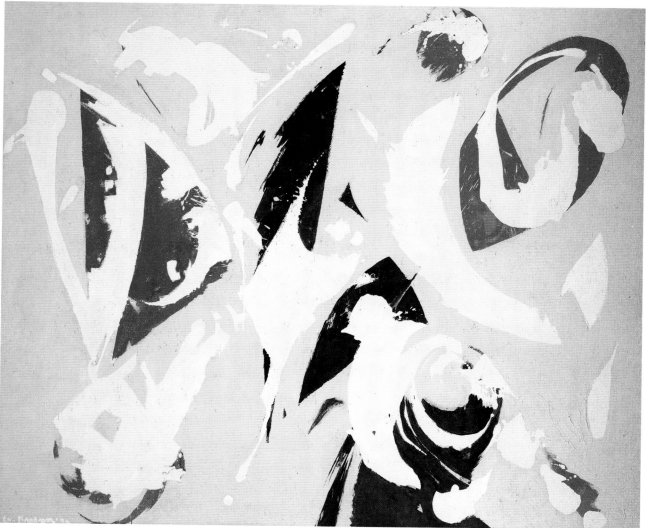

76

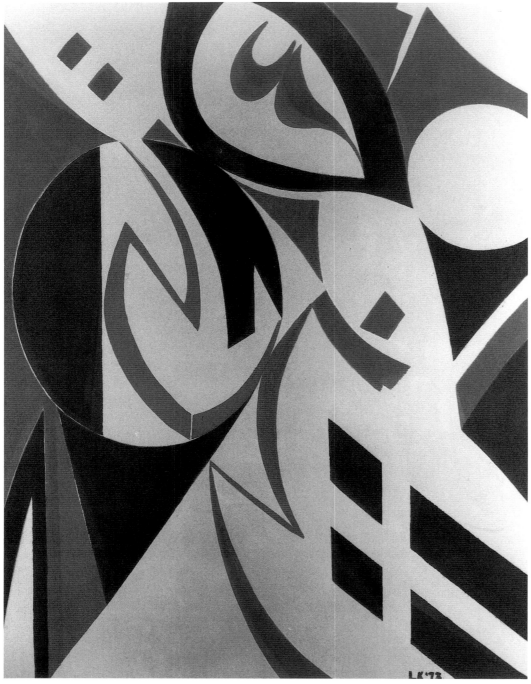

77

evident her continued interest in outer space, but her insistent
formality resulted in a fresh alliance of astronomy and callig-
raphy, yielding a new alphabet of the cosmos, which viewers
can recognize even if they cannot read it. New knowledge is
again regarded as an explosion, but this time it is a premedi-
tated, precisely articulated explosion. The distilled forms in the
painting reveal a knowledge of hard-edge painting ranging from
Roy Lichtenstein's Pop icons to Stella's Protractors (which deal
with the same Celtic interlace that had fascinated Krasner for
years).

In *Palingenesis*, Krasner returned again to *Sun Woman II* and
The Seasons, as she had done six years earlier in *Combat*.

4, 3

56, 69

Although the iconography is similar in all four works, *Palingenesis* is the most formal and restrained, reflecting an intimate understanding of Matisse's cutouts. Its title (which refers to the passing of the soul from one body to another at the moment of death) underscores its ritualistic nature and its visual affinities with a carefully cadenced procession.

In both *Rising Green* and *Mysteries* Krasner continued the theme of *Palingenesis*, but instead of rebirth these spare and elegant works express the idea of growth. Both paintings are built of silhouetted forms—flowers, buds, and leaves in *Rising Green*, a tulip and bud in *Mysteries*. Drips of paint in both pieces are subjected to the same discipline as the rest of the painting, imbuing both works with the sense of suspension in time. 79, 100

Refinement and discipline continued to mark Krasner's art, as an examination of *In My Looking Glass* and *Olympic* indicates. In the former work shapes recalling Near Eastern calligraphy are used to create an abstracted figure on the right peering into an equally abstract mirror on the left. The painting may be a reworking of Picasso's *Girl before a Mirror*, which had fascinated Krasner decades earlier. Also, in the 1960s and early 1970s a number of Iranian calligraphic painters were living in 77, 78

43

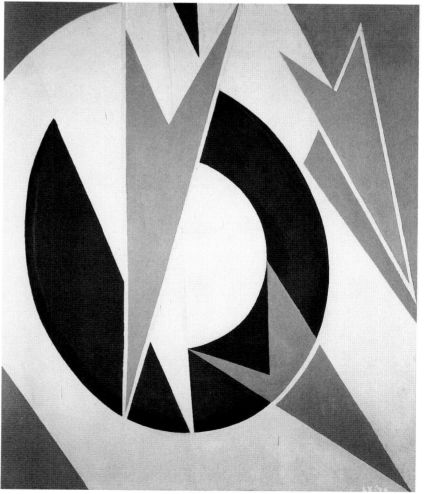

77. *In My Looking Glass,* 1973
Oil on canvas, 74⅝ x 58¼ in. (189.5 x 148 cm)
The Estate of Lee Krasner; Courtesy Robert
Miller Gallery, New York

78. *Olympic,* 1974
Oil on canvas, 82½ x 70½ in. (209.6 x 179.1 cm)
The Estate of Lee Krasner; Courtesy Robert
Miller Gallery, New York

78

Paris. Their art became part of what is known as the Letterist movement, and Krasner's art reflects either a knowledge of this art or its ancient precursor in the Near East. The greater sense of reductiveness of *Olympic* is closer to Krasner's rigorous AAA works in the style of Mondrian and to her subsequent mural designs for WNYC. It is as if she has taken a detail of one of her most abstract mural designs, removed the black cloisonné outlines, and blown up the result to monumental scale. Yet for all its apparent structure, *Olympic* is breaking apart, undermining rather than perpetuating the cohesiveness and optimism of Stella's Protractors. *Olympic* is important both as a radical shift toward a more Minimalist vocabulary and as an abstract armature for Krasner's next series.

That series, first exhibited in 1977 at Pace Gallery in the exhibition *Lee Krasner—Eleven Ways to Use the Words to See,* caught the New York art world by surprise because it represented a radical rethinking of the then sacrosanct modernist tradition by an artist long overdue for confirmation as one of its masters. Coming at a time when modernism was beginning to be regarded as bankrupt, this self-assured exhibition reinforced the suspicions of modernism's end.

The official story of *Eleven Ways* that Krasner told on numerous occasions is that in 1974 her friend the British curator Bryan Robertson had found in her barn at The Springs a group of old charcoal and oil drawings that she had made at Hofmann's school in 1937–40. Many were studies of the live model. After going through the works and deciding to have some of them framed, Krasner put aside the rest to be destroyed. Later she found the portfolio of rejects in her New York apartment and decided to use them for a series of collages. According to John Bernard Myers, who reconstructed a conversation with the artist, Krasner stated, "The first collage of the new work is called *Imperative* [1976]—meaning I experienced the need not just to examine these drawings but a peremptory desire to change them, a command as it were, to make them new."[76]

What Krasner and her chroniclers have omitted from her story is that in 1975 the art critic Gene Baro organized the circulating exhibition *Lee Krasner: Collages and Works on Paper, 1933–1974.* That same year the Marlborough Prints and Drawings Gallery featured a solo exhibition of her early modernist pieces entitled *Works on Paper: 1937–1939.* During the preparations for both exhibitions, Krasner had ample opportunity to reexamine her early works, to study her collages, and to see potential relationships between the two.

At the same time, the artist Miriam Schapiro, whom Krasner had known in the 1950s, was reinterpreting collage from a feminist perspective.[77] Schapiro, like Krasner, was carrying on an aesthetic dialogue with Stella's Protractor series, but she was reinterpreting them as giant appliqués and slowing down Stella's instantaneous gestalts by using elaborately decorated materials that invited close study. Krasner, in turn, entered into a conversation with Schapiro's collages and also with feminism, which was

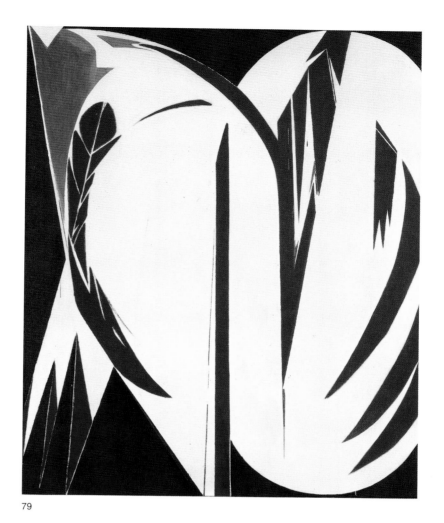

79

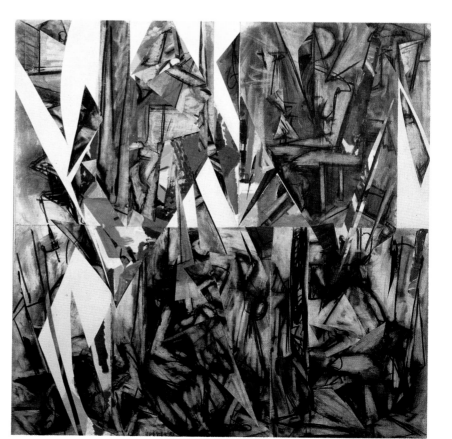

79. *Rising Green,* 1972
Oil on canvas, 82 x 69 in. (208.2 x 175.2 cm)
Metropolitan Museum of Art, New York; Gift of
Mr. and Mrs. Eugene Victor Thaw

80. *Imperative,* 1976
Collage on canvas, 50 x 50 in. (127 x 127 cm)
National Gallery of Art, Washington, D.C.; Gift
of Mr. and Mrs. Eugene Victor Thaw in honor
of the 50th anniversary of the National Gallery
of Art

80

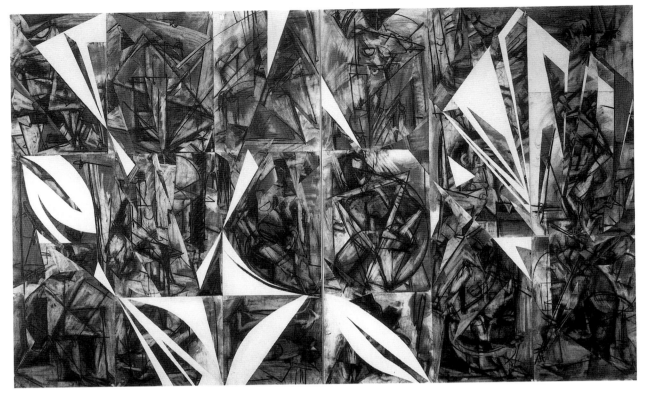

81

becoming an important artistic subject in the 1970s. Instead of using fabric, Krasner appliquéd sections of her own drawings to canvas. This process was not a new one for Krasner, who had been recycling her rejects for several decades. But taking recent works and reusing them is a vastly different proposition, psychologically, from going back to one's student efforts and reworking them. The subject of this new series was the history of modern art, which was also Krasner's history. By incorporating her least interesting drawings into these pieces, she made a statement about the need to critique and rework the past. (These collaborations with her youth may also have been informed by some of Pierre Alechinsky's contemporaneous artistic collaborations with other artists, poets, and the authors of old letters found in flea markets.)

In *Eleven Ways* the past is viewed as a series of fragments, unobtainable in its entirety and understandable only retrospectively and incompletely. The series presents an oblique and warped view of the artist's past, and in particular her failures. But Krasner's student works serve not only as the unseen background of her mature art but also as formal elements within it, subject to editing in order to create forceful compositions in the present.

The titles for the collages originated with Krasner's friend Saul Steinberg,[78] who has been concerned in his own work with art as language and with seeing as an encoded process. Although Krasner was probably unaware of the term "deconstruction" (and although only a few critics and historians have applied the term to this series), these works are in fact deconstructions of modernism. Her drawings from the Hofmann

81. *Diptych*, 1977–78
Collage on canvas, 66 x 114 in.
(167.6 x 289.6 cm)
Private collection; Courtesy Robert Miller Gallery, New York

82. *Past Conditional*, 1976
Collage on canvas, 27 x 49 in.
(68.6 x 124.5 cm)
The Estate of Lee Krasner; Courtesy Robert Miller Gallery, New York

School embody a host of conventions that she regarded as no longer relevant modes of seeing and as inadequate representations of reality. Through her radical cuts, Krasner acknowledged the drawings' inadequacy and their provisional status as works of art but also reinforced the fact that the series of new collages depended on them for its full meaning. Krasner's use of "words" as a basis for her series parallels the emphasis on language studies by many artists—including Conceptualists, Neo-Expressionists, and appropriators—beginning in the late 1960s and continuing to the present. Krasner's interest in language and her act of undermining the content of her early drawings placed her in the forefront of postmodernism even though she still thought of herself as a modernist. In some of these works she used rubbings from the charcoal drawings that appeared on the protective sheets interspersed between them. These faint impressions resemble erasures and leave viewers perplexed as to whether they are real drawings or pale reflections, thus making the conditional verb tense cited in the titles of some works in the series particularly appropriate. In *Past Conditional* Krasner 82 employed two overlapping but nonalignable systems. One is the Hofmann-derived style of the original drawings, the other is the internal rhythm of the collage itself. *Past Conditional* connotes the problems of trying to work with radically different systems—a problem all too familiar in this computer age, when different types of software, representing discrete forms of logic, are so often incompatible.

Imperfect Indicative provides an excellent example of how 85 Krasner edited her past to propel it into a new realm of understanding. She left some drawings in this collage complete while fracturing and recombining others into abstract shapes that

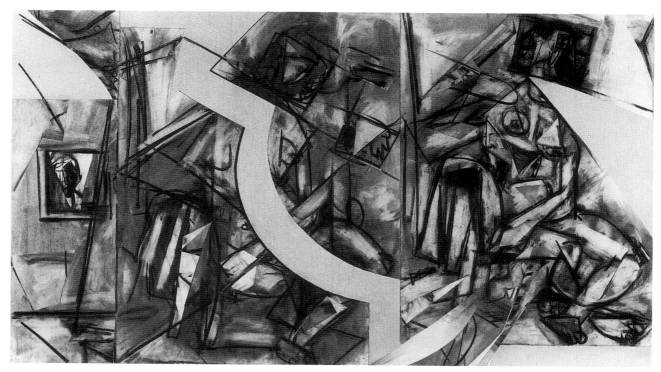

82

recall the Celtic and medieval manuscripts so important to her. The cut-up drawings in *Imperfect Indicative* retained only traces of their past identity, becoming embellishments of new ideas.

Krasner set out to critique only her own past in *Eleven Ways to See,* but she ended up taking on that part of the modernist enterprise that Hofmann had synthesized and codified. In this series she began to critique modernist art generally, as opposed to individual artist's styles, and to find it woefully lacking. This distrust of modernism infused some of her last works, so that the final period of her career became a time when she alternated between belief and. disbelief.

The trenchancy of Lee Krasner's personal critique and her courage in still trying to break through limits continued in some of the works made during the last five years of her life. The increased critical attention to her art generated by important shows and a retrospective encouraged her to become reacquainted with various aspects of her past and to oscillate between searching self-criticism and thoughtful, well-deserved self-congratulation.

On occasion she reconceived some of the themes important to her in a distinctly new way. A significant late modernist work is *Crisis Moment,* an abstracted still life consisting of blossoms resembling blood. The mixture of violence and beauty—unexpected though not unprecedented in her oeuvre—gives new meaning to the French term for still life, *nature morte* (literally, "dead nature"). Some of the flowers or buds resemble egg shapes, complicating still further the intermingling of life and death, birth and growth.

In Krasner's *Between Two Appearances,* she contrasted two codes of expression: spontaneous drips and thoughtful representation. By cutting the drips out of older works, she transformed them into distinct signs for feeling—in effect, putting quotation marks around the drips and giving them an element of the Neo-Expressionist irony then prevalent in the art world. The fact that the heads in the painting are not collaged and look as if they were created with genuine feeling heightens the quality of doubt, causing one to suspect that they may be real while the drips are counterfeit. But the drips are actual; it is only the excision that makes them look unnatural. The two appearances of the title thus become two contradictory illusions that the artist chose not to resolve.

Although some critics and art historians may persist in referring to Lee Krasner as Mrs. Jackson Pollock, she was far more than that: a modernist in the reactionary 1930s; a first-generation Abstract Expressionist in the 1940s; an incipient feminist who mounted a critique of the macho-oriented styles of Pollock, de Kooning, and Motherwell (among others) in the 1950s; a visionary in the late 1950s and early 1960s; a late Abstract Expressionist willing to accommodate aspects of color-field and hard-edge painting in the mid-to-late 1960s; and a significant postmodernist in the 1970s and early 1980s.

83. *Crisis Moment,* 1980
Oil and paper collage on canvas, 69 x 54¾ in.
(175.3 x 139.1 cm)
Private collection; Courtesy Robert Miller Gallery, New York

84. *Between Two Appearances,* 1981
Oil and paper collage on canvas, 47 x 57¼ in.
(119.3 x 145.4 cm)
The Estate of Lee Krasner; Courtesy Robert Miller Gallery, New York

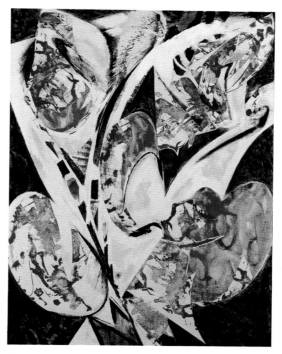

83

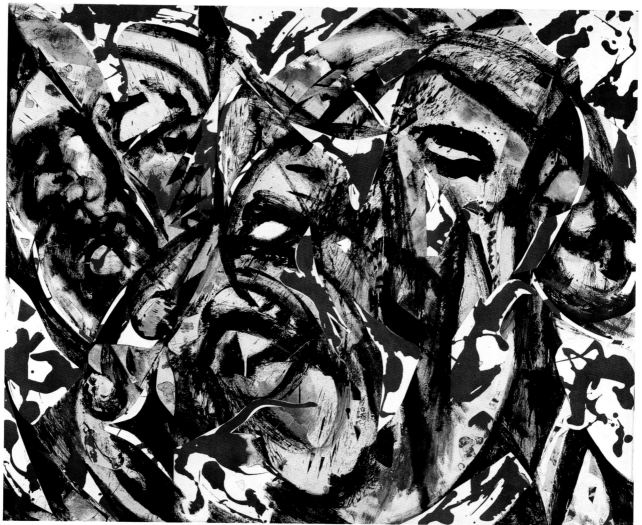

84

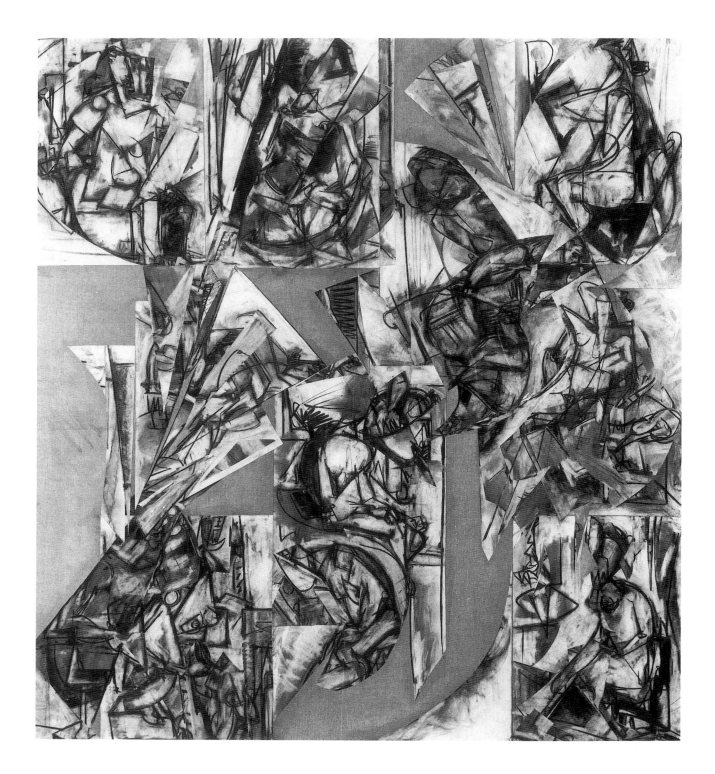

85. *Imperfect Indicative,* 1976
Collage on canvas, 78 x 72 in.
(198.1 x 182.8 cm)
Estate of Lee Krasner;
Courtesy Robert Miller Gallery,
New York

In her work Krasner always insisted that modern art must be international and never parochial. Because her work was predicated on an understanding of the self as dynamic and interactive, she was never content to establish a singular style to connote her own individuality, as many of the other Abstract Expressionists did. Rather, she embraced change, which generally took shape through a highly charged dialogue with other artists and herself.

NOTES

1. Barbara Cavaliere, "An Interview with Lee Krasner," *Flash Art,* nos. 94–95 (January–February 1980): 15. As a way of commending Arshile Gorky, Krasner stated that he "at least gave me a level to fight on."

2. John Graham, *System and Dialectics of Art,* ed. Marcia Epstein Allentuck (Baltimore: Johns Hopkins Press, 1971), p. 119.

3. Krasner, interview with Robert Hobbs and Gail Levin, The Springs, New York, August 1977.

4. John Bernard Myers, *Tracking the Marvelous: A Life in the New York Art World* (New York: Random House, 1981), p. 103.

5. Lillian Olinsey Kiesler, interview with Robert Hobbs, New York, April 1991.

6. Krasner, in Cavaliere, "Interview with Lee Krasner," p. 16.

7. Eleanor Munro, *Originals: American Women Artists* (New York: Simon and Schuster, 1979), p. 104.

8. Ellen G. Landau, "Lee Krasner's Past Continuous," *Artnews* 83 (February 1984): 76.

9. Krasner, in Steven Naifeh and Gregory White Smith, *Jackson Pollock: An American Saga* (New York: Clarkson N. Potter, 1989), p. 368.

10. Krasner, in Munro, *Originals,* p. 116.

11. Krasner, in Cindy Nemser, *Art Talk: Conversations with Twelve Women Artists* (New York: Charles Scribner's Sons, 1975), p. 83.

12. Ibid., p. 84.

13. Mary D. Garrard, "Artemesia Gentileschi's Self-Portrait as the Allegory of Painting," *Art Bulletin* 62 (March 1980): 97–112.

14. Krasner, in John Bernard Myers, "Naming Pictures: Conversations Between Lee Krasner and John Bernard Myers," *Artforum* 23 (November 1984): 71.

15. Krasner, in Charlotte Willard, "Eye to I," *Art in America* 54 (March–April 1966): 55.

16. William A. Phillips, *A Partisan Review: Five Decades of the Literary Life* (New York: Stein and Day, 1983), p. 67.

17. Lionel Abel, "Harold Rosenberg: 1906–1978," *Artnews* 77 (Summer 1978): 76–77.

18. Krasner, in Barbaralee Diamonstein, *Inside New York's Art World* (New York: Rizzoli, 1980), p. 206.

19. Leon Trotsky, "A Letter to the Editors of *Partisan Review,*" trans. Nancy MacDonald and Dwight MacDonald, *Partisan Review* 5 (June 18, 1938): 3, 10.

20. Krasner, in Barbara Rose, *Lee Krasner: A Retrospective* (Houston: Museum of Fine Arts; New York: Museum of Modern Art, 1983), p. 37.

21. Ellen G. Landau, "Lee Krasner: A Study of Her Early Career (1926–1949)" (Ph.D. diss., University of Delaware, 1981), p. 38 n. 12.

22. Ibid., p. 54.

23. Arthur Rimbaud, *A Season in Hell,* trans. Delmore Schwartz, 2d ed. (Norfolk, Conn.: New Directions, 1940), p. 27.

24. Krasner, in Munro, *Originals,* p. 11.

25. Rose, *Retrospective,* p. 70.

26. Rimbaud, *Season in Hell,* p. 67.

27. In the past, scholars have regarded Krasner's inscription of Rimbaud's question "What beast must be adored?" as predictive of her love for Pollock. The question, as I have shown, can also be considered as symbolic, with the beast being the specter of Krasner's own dreams and unconscious motives. Pollock can be considered a manifestation of these motives and a response to Krasner's own needs.

28. Cynthia Goodman, *Hans Hofmann* (New York: Abbeville Press, 1986), pp. 36ff.

29. Rose, *Retrospective,* p. 24.

30. Wolf Kahn, "Hans Hofmann's Good Example," *Art Journal* 42 (Spring 1982): 22.

31. Hofmann, in David Bourdon, "Lee Krasner: 'I'm Embracing the Past,'" *Village Voice,* March 7, 1977, p. 57.

32. Munro, *Originals,* p. 108. In conversation with Munro, Krasner described de Kooning's model as a "life-size sketch."

33. Landau, "Study of Her Early Career," p. 84.

34. Krasner, in Bourdon, "'I'm Embracing the Past,'" p. 57.

35. Rose, *Retrospective,* p. 40.

36. I gratefully acknowledge my conversation with Fredrika H. Jacobs (Richmond, Virginia, January 1992), who helped me formulate this idea.

37. The artist Dorothy Dehner (foreword in Graham, *System and Dialectics of Art,* pp. xiii–xxl) communicates the excitement that Graham was able to create.

38. Ellen Landau, "Lee Krasner's Early Career, Part One: 'Pushing in Different Directions,'" *Arts Magazine* 56 (October 1981): 120.

39. Naifeh and Smith (*Jackson Pollock,* pp. 394–95) cite a number of friends and associates who question Krasner's instant recognition of Pollock's genius.

40. Krasner, in Munro, *Originals,* p. 112.

41. According to May Tabak, Krasner's new, severely plain look may have been prompted by Pollock: "I had lunch with them [Lee and Jackson] and his mother. Lee took out a lipstick and Jackson said, 'No makeup.' Lee was taken aback because she always used lipstick, maybe a little rouge. She said, 'But everybody does, Jackson, even your mother does!' He said he couldn't talk about his mother that way, and Lee was frightened by his rage at this terrible insult to his mother." (Jeffrey Potter, ed., *To a Violent Grave: An Oral Biography of Jackson Pollock* [Wainscott, N.Y.: Pushcart Press, 1987], p. 68.)

42. Ibid., p. 86.

43. Myers, *Tracking the Marvelous,* p. 104.

44. Krasner, in Munro, *Originals,* p. 114. Krasner has emphasized that they rarely discussed art during these times. (Ibid.)

45. Rose, *Retrospective,* p. 54.

46. B. H. Friedman has noted that Krasner called her paintings made from late 1946 to 1950 "hieroglyphs." (Friedman, introduction to *Lee Krasner: Paintings, Drawings and Collages* [London: Whitechapel Art Gallery, 1965], p. 10). Eight years later Krasner remarked, "Finally in '46 what I called 'Little Image' began breaking through this gray matter of mine." (Cindy Nemser, "A Conversation with Lee Krasner,' *Arts Magazine* 47 [April 1973]: 44.)

47. Landau ("Study of Her Early Career," pp. 244–57) provides a clear analysis of the reviews of the exhibition.

48. Ellen G. Landau, "Lee Krasner's Early Career, Part Two: The 1940s," *Arts Magazine* 56 (November 1981): 89. In this essay Landau notes, "Krasner states that she had absorbed Mondrian's 'Pier and Ocean' Series into her fund of visual images by the time she painted these works."

49. Robert Hobbs, "Early Abstract Expressionism and Surrealism," *Art Journal* 45 (Winter 1985): 299–302.

50. Michael Cannell, "An Interview with Lee Krasner," *Arts Magazine* 59 (September 1984): 88.

51. Krasner, in Diamonstein, *Inside New York's Art World,* p. 205.

52. Krasner, in Barbara Novak, *Lee Krasner: Recent Work* (New York: Pace Gallery, 1981), n.p.

53. Krasner, in Myers, "Naming Pictures," p. 73.

54. At the same time Ad Reinhardt was painting a series of red paintings, and Robert Rauschenberg had a show of all-red paintings in 1954, which may have had a similar political subtext. Surprisingly, this interpretation of these artists' work as oblique references to the Red Scare has not previously been noted.

55. Harold Rosenberg, "The American Action Painters," *Artnews* 52 (Spring 1952): 22–23, 48ff.

56. Bryan Robertson and Robert Hughes, *Lee Krasner Collages* (New York: Robert Miller Gallery, 1986), n.p.

57. Two books by Harry Stack Sullivan provide an overview of his ideas: *Clinical Studies in Psychiatry,* ed. Helen Swick Perry, Mary Ladd Gawel, and Martha Gibbon (New York: W. W. Norton and Company, 1956), and *The Interpersonal Theory of Psychiatry,* ed. Helen Swick Perry and Mary Ladd Gawel (New York: W. W. Norton and Company, 1953).

58. Tabak, in Potter, ed., *To a Violent Grave*, p. 162.

59. Downs, ibid.

60. Krasner, in Munro, *Originals*, p. 116.

61. Rose, *Retrospective*, p. 95.

62. Krasner, interview with Hobbs and Levin. Even two decades after Pollock's death and de Kooning's affair with Kligman, Krasner was still bitter. Her fury extended to de Kooning's work: "Well, with regard to de Kooning, certainly he is one of the leading forces in this movement. With regard to his series on *Woman*, I reject them one hundred percent; I find them offensive in every possible sense; they offend every aspect of me as a woman, as a female." (Krasner, interview with Dolores Holmes, 1972, Archives of American Art, Smithsonian Institution, Washington, D.C., p. 5.)

63. Krasner, in Cindy Nemser, "The Indomitable Lee Krasner," *Feminist Art Journal* 4 (Spring 1975): 9.

64. Krasner, in Landau, "Lee Krasner's Past Continuous," p. 76.

65. Krasner, in Richard Howard, *Lee Krasner: Paintings, 1959–1962* (New York: Pace Gallery, 1979), n.p.

66. There are few references in the literature to Krasner's iconography. The major exceptions are Marcia Tucker, *Lee Krasner: Large Paintings* (New York: Whitney Museum of American Art, 1974), and Bryan Robertson's essays.

67. Krasner, in Tucker, *Lee Krasner: Large Paintings*, p. 8.

68. Howard, *Lee Krasner: Paintings, 1959–1962*, n.p.

69. Krasner, ibid.

70. Krasner, interview with Seckler, December 14, 1967, p. 11.

71. Ralph Waldo Emerson, *Essays and Lectures: Second Series* (Columbus, Ohio: Charles E. Merrill Publishing Company, 1969), p. 265.

72. Howard, *Lee Krasner: Paintings, 1959–1962*, n.p.

73. Ibid.

74. Krasner, ibid.

75. Krasner, in Munro, *Originals*, p. 119.

76. Krasner, in Myers, "Naming Pictures," p. 71.

77. Both Miriam Schapiro and her husband, Paul Brach, had known the Pollocks in the early 1950s, when Brach was close to Pollock. Because of this early association, Krasner would certainly have been alert to the critical attention that Schapiro was receiving as a leader of the feminist movement.

78. Jeanne Siegel, *Collage Expanded* (New York: Visual Arts Museum, 1984), n.p.

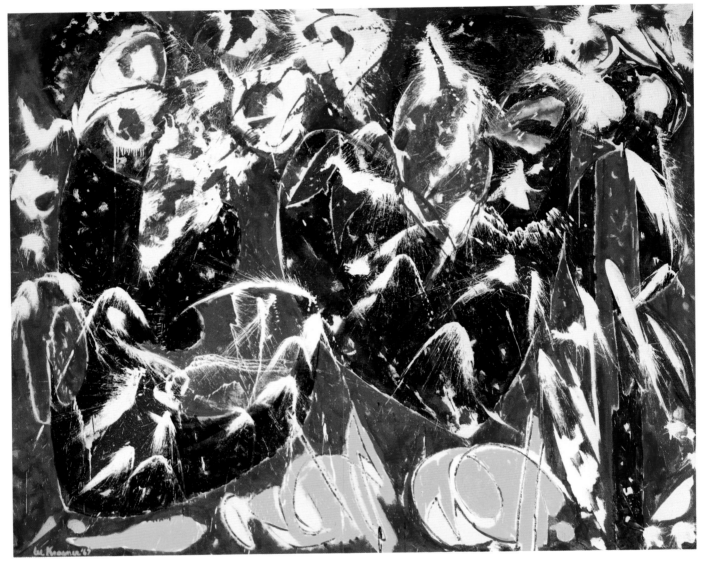

86

Artist's Statements

"[Seeing Matisse and Picasso at the Museum of Modern Art] was an upheaval for me, something like reading Nietzsche and Schopenhauer. A freeing . . . an opening of a door. I can't say what it was, exactly, that I recognized, any more than some years earlier I could have said why it was I wanted to have anything to do with art. But I know one thing, beyond the aesthetic impact: seeing those French paintings stirred my anger against any form of provincialism. When I hailed those masters I didn't care if they were French or what they were. Nowadays again, when I see those big labels, 'American,' I know someone is selling something. I get very uncomfortable with any kind of chauvinism—male, French or American."

Quoted in Eleanor Munro, *Originals: American Women Artists* (New York: Simon and Schuster, 1979), pp. 106–7.

"Painting, for me, when it really 'happens' is as miraculous as any natural phenomenon—as say, a lettuce leaf. By 'happens,' I mean the painting in which the inner aspect of man and his outer aspects interlock. One could go on forever as to whether the paint should be thick or thin, whether to paint the woman or the square, hard-edge or soft, but after a while such questions become a bore. They are merely problems in aesthetics, having only to do with the outer man. But the painting I have in mind, painting in which inner and outer are inseparable, transcends technique, transcends subject and moves into the realm of the inevitable—then you have the lettuce leaf."

Quoted in Bryan Robertson and B. H. Friedman, *Lee Krasner: Paintings, Drawings and Collages* (London: Whitechapel Art Gallery, 1965), n.p.

"When one starts using the unconscious as a source to take off, it doesn't mean that it's an unconscious painting because the consciousness is there. The artist is there. You're aware. . . . I'm not interested in a priori theory when I paint my picture, because I think you get an awful lot of dead painting, not interesting, dead,

86. *Uncial*, 1967
Oil on canvas, 68 x 85 in. (172.7 x 215.9 cm)
Dr. and Mrs. J. H. Hirschmann, Winnetka, Illinois; Courtesy Robert Miller Gallery, New York

sterile. . . . And if you say I cut off the dream part of me, well, that's like dealing with a part of yourself. And I think it's more exciting to pursue a total person, a total experience if you can reach it."

Lee Krasner, interview with Dorothy Seckler, December 14, 1967, Archives of American Art, Smithsonian Institution, Washington, D.C., p. 13.

"I am preoccupied with trying to know myself in order to communicate with others. Painting is not separate from life. It is one."

Quoted in Louise Rago, "We Interview Lee Krasner," *School Arts* 60 (September 1960): 32.

"My painting is so autobiographical, if anyone can take the trouble to read it."

Quoted in Cindy Nemser, "The Indomitable Lee Krasner," *Feminist Art Journal* 4 (Spring 1975): 9.

"As a painter, I never thought of myself as anything but LEE KRASNER. I'm always going to be Mrs. Jackson Pollock—that's a matter of fact—but I've never used the name Pollock in connection with my work. I painted before Pollock, during Pollock, after Pollock."

Quoted in David Bourdon, "Lee Krasner: 'I'm Embracing the Past,'" *Village Voice*, March 7, 1977, p. 57.

"If the alphabet is A to Z, I want to move with it all the way, not only from A to C. For me, all the doors are open. One can't stop growing though it takes enormous energy to keep growing and it is painful. Yet I have never been able to understand the artist whose image never changes.

"The *Stations of the Cross* [by Barnett Newman] doesn't interest me. Rothko too took a single image and stayed with it. I have never understood that. My images are always open.

"I believe in listening to cycles. I listen by not forcing. If I am in a dead working period, I wait, though those periods are hard to deal with."

Quoted in Munro, *Originals*, p. 119.

"I never violate an inner rhythm. I loathe to force anything. . . . I don't know if the inner rhythm is Eastern or Western. I know it is essential for me. I listen to it and I stay with it. I have always been this way.

"I have regards for the inner voice."

Krasner, "She Has Been There Once or Twice," interview with Gaby Rodgers, 1977, Archives of American Art.

"It's too bad that women's liberation didn't occur thirty years earlier in my life. It would have been of enormous assistance at that time. I couldn't run out and do a one woman job on the whole masculine art world and continue my paintings and stay in the role I was in as Mrs. Pollock. What I considered important

was that I was able to do my work and other things would have to take their turn. Rightly or wrongly I made my decision."

Quoted in Cindy Nemser, "Lee Krasner's Paintings 1946–49," *Artforum* 12 (December 1973): 65.

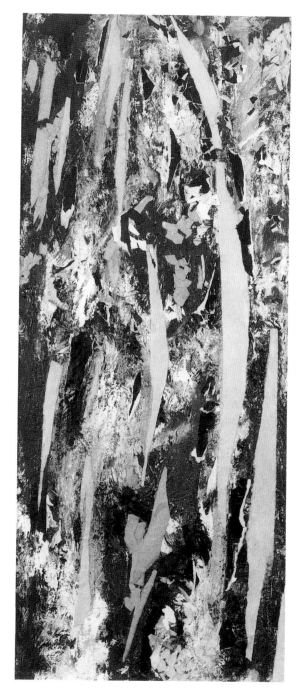

87. *Forest,* 1955
Oil and collage on board, 50 x 20 in.
(127 x 50.8 cm)
Robert Miller Gallery, New York

87

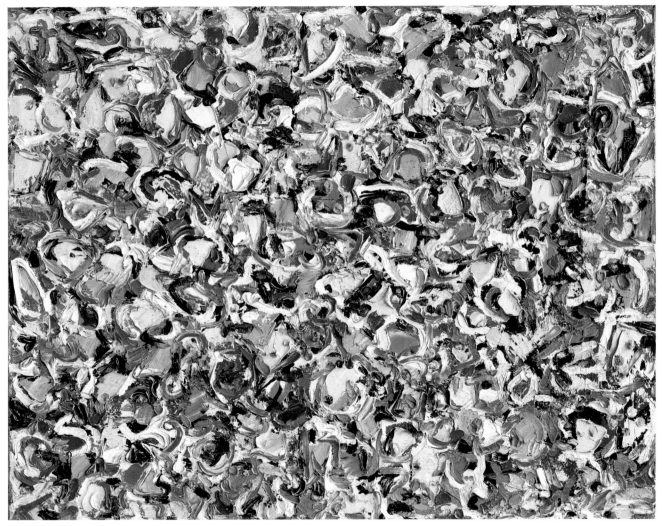

88

Notes on Technique

Before she became an Abstract Expressionist, Krasner reveled in the sensuousness of oil paint. Her early studies at the National Academy of Design as well as her works shown at the American Abstract Artists exhibitions were thickly impastoed. Her liberal use of materials during the Depression bespeaks an expansive and hedonistic attitude toward her art and herself. This expansiveness continued to be central to Krasner's working method in the 1940s. Even when she and Pollock worried about money for essentials such as food and firewood, they both were extravagant with art materials. Krasner's gray slabs made about 1943–46 were thickly encrusted with numerous layers of heavy paint. (She and Pollock eventually soaked and scraped off the paint so that many of these canvases could be used again.)

In the second half of the 1940s, when Pollock was experimenting with commercial house-painting enamels and aluminum paint, Krasner continued to work almost exclusively with oils. In response to Pollock's innovations of pouring and dripping pigment on unstretched canvases, she began cutting her oils with turpentine to obtain "the consistency of a thick pouring quality."[1] She continued to stretch her canvases, placing those for her Little Image paintings either on the floor or on a table in order to work.[2] In that series she used a mixture of approaches: dripping delicate skeins of paint in *Continuum*, applying rich impastoes with a palette knife in *Noon*, thickly brushing on signs in the hieroglyphs, and also digging into the surface with the end of her brush to make scattered marks in many of these works.

From Pollock, she learned to use a stiff brush together with a can of paint liquid enough to pour, but she felt more comfortable with traditional approaches of applying oils. Whereas Pollock painted with his whole body, in a carefully cadenced, almost ritualistic dance, Krasner was more cautious and relied on movements of the wrist. She characterized her approach in the Little Images as a "controlled dripping situation, very controlled and sustained."[3]

88. *Noon,* 1947
Oil on linen, 24 x 30 in. (60.9 x 76.2 cm)
Robert Miller Gallery, New York

103

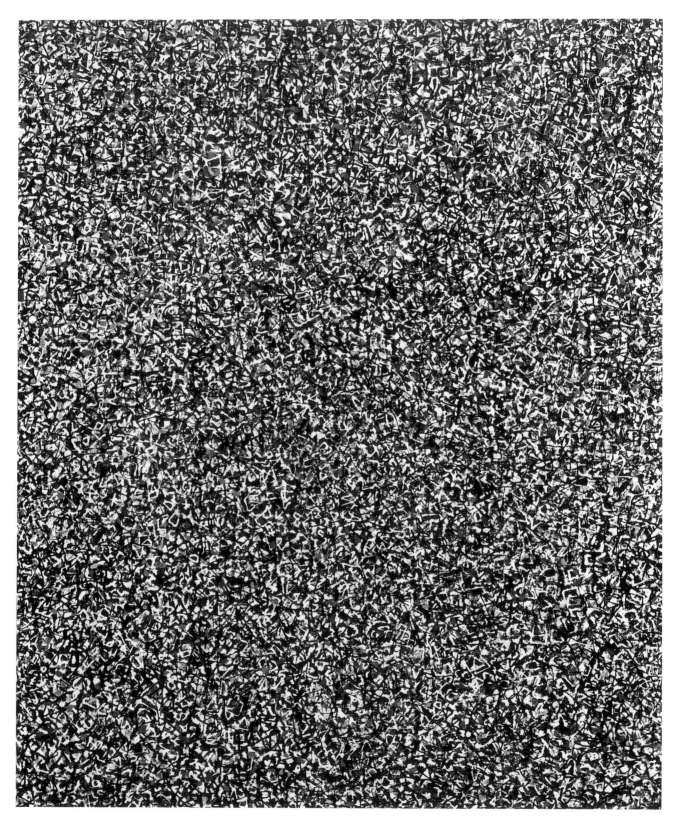

89

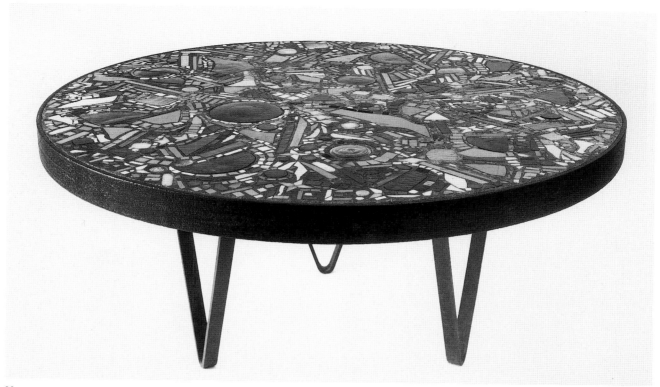

90

89. *Continuum*, 1947–49
Oil and enamel on canvas, 53 x 42 in.
(134.6 x 106.7 cm)
Private collection; Courtesy Robert Miller
Gallery, New York

90. *Mosaic Table*, 1947
Mosaic and mixed media, diameter: 48 in.
(121.9 cm)
Jason McCoy, Inc., New York

When Krasner began making large horizontal paintings in the late 1950s and early 1960s, she would tack unstretched canvas to the wall and size it with Rivet, a transparent glue that prevented paint from permeating the cloth. The position of the painting on a vertical support required her to fling brush loads of paint against the canvas, which resulted in the drips and furred swathes that are notable in her works of this period.

In an interview with John Bernard Myers, Krasner recalled that both she and Pollock had been influenced by the Surrealist method of psychic automatism.[4] Basically, psychic automatism is an improvisational method of working, during which an artist encourages the hand and mind to wander so that aspects of the unconscious mind can be revealed. The first stage customarily is a period of getting acquainted with oneself and the chosen medium. At this point only random marks are encouraged. As Krasner later explained, "Mostly I started [the Little Images] on a raw canvas with my first markings and let it evolve . . . [and] I kept working and reworking and reworking till I got what I felt I wanted to leave it at."[5] This period of reworking can be "both a battle and at times an instantaneous contact," according to Krasner.[6] It is a process of working with oneself as much as with the painting.

Psychic automatism encouraged Krasner to view the making of her art as an emotionally charged process and to consider her work with the same ferocity with which she sometimes regarded herself. Bluntly cutting, forcefully ripping, and at times gently tearing paper became key processes in creating many of her collages, and in some works she frayed pieces of canvas to create loose threads and raveled edges. Because of her success with collages, Krasner began to consider that medium as a means of

91

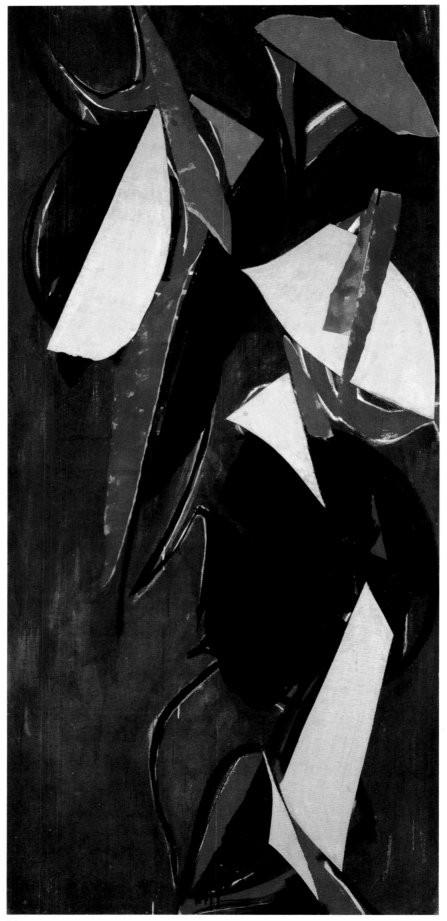

91

92

91. *Image on Green (Jungle)*, 1955
Oil and collage on canvas, 82¾ x 39 in.
(210.2 x 99.1 cm)
Meredith Long & Company, Houston;
Courtesy Robert Miller Gallery, New York

92. *Mural*, Uris Building, 2 Broadway, New
York, 1958–59
Mosaic, approximately 12½ x 86 ft.
(3.8 x 26.2 m.)

renewal, and she returned to it periodically. In her collage paintings she would start by pinning pieces of paper to a rejected
canvas. After deciding that a certain composition worked, she
would take the canvas down and permanently affix the pieces
with glue, then add additional colors to unify the work even
more through judicious painting.

Krasner's interest in collage relates to her occasional experiences with mosaic. In 1947 she took some tesserae that Pollock
had left over from a WPA project and used them to make two
mosaic tables, along with a variety of other materials. A decade
later she was commissioned to create a monumental mosaic
mural for the Uris Building, at 2 Broadway in New York. For this
commission, which Krasner undertook with her nephew Ronald
Stein, she intended to do the construction herself, breaking the
pieces of Italian glass used for the mosaic and arranging them
into an improvised composition based on a general plan. Unfortunately, union laws prevented her from working directly with
the materials, and she had to let workmen break and assemble
the glass into her design.

The mosaic for the Uris Building was the only occasion when
Krasner worked on a truly monumental scale. In her paintings

90
92

93

she wanted to keep the overall size in proportion to her own
body, even though the proportion of her large canvases at times
necessitated reaching high and even making "a leap off the floor
with a long-handled brush."[7] The intimate relationship between
her body and the large canvas were of great psychological impor-
tance to her.

Because natural light was crucial to Krasner's sense of color,
whenever she had to work under artificial illumination, she limited
the range of her hues. But when working in natural light, she
experimented with color in distinctly original ways. Although she
had a great affinity for color, she preferred to work with colors that
would jar viewers.[8] Krasner's favorite palette was a small table with
wheels attached. She would usually mix colors on the tabletop; on
occasion she would mix them directly on the work itself.

Krasner always seemed content to work in whatever space
was available. When she and Pollock first moved to The
Springs, she worked downstairs while he painted in the upstairs
bedroom. Later, after they moved the barn and converted it into
a studio for him, she took over the extra bedroom as her studio.
After Pollock's death, she moved into his studio. Soon there-

93. Lee Krasner at work in her studio, 1981
Photograph by Ernst Haas

after, she bought an apartment in New York and remained there during the winters and spent summers on Long Island. Although one might have expected her to make only small paintings in her apartment in Manhattan and large ones in The Springs, she managed to work on a relatively large scale even in the city.

Although Krasner made a number of important prints, she clearly preferred to work with media—painting, collage—that permitted her direct involvement at every stage. Her favored tools were brushes, palette knives, and scissors, which allowed her to maintain intimate contact with the work. When she did make prints, Krasner was most comfortable with lithography because of its dependence on drawing.

Unlike the color-field painters, Krasner never became completely involved in purely formal issues. Her artistic decisions were doubly important because the final result represented both an artwork and an integral aspect of herself. This double-edged aspect of her technique often made the process of painting particularly difficult because of the emotional risks involved. It also made her most successful works awe-inspiring in their authenticity and conviction.

NOTES

1. Krasner, in Cindy Nemser, *Art Talk: Conversations with Twelve Women Artists* (New York: Charles Scribner's Sons), p. 89.

2. Ibid.

3. Krasner, in Ellen G. Landau, "Lee Krasner's Early Career, Part Two: The 1940s," *Arts Magazine* 56 (November 1981): 84.

4. Cindy Nemser, "Lee Krasner's Paintings, 1946–49," *Artforum* 12 (December 1973): 61.

5. Krasner, interview with Dorothy Seckler, December 14, 1967, Archives of American Art, Smithsonian Institution, Washington, D.C.

6. Krasner, interview with Seckler, April 11, 1968.

7. Krasner, in Marcia Tucker, *Lee Krasner: Large Paintings* (New York: Whitney Museum of American Art, 1974), p. 16.

8. Krasner, interview with Seckler, April 11, 1968.

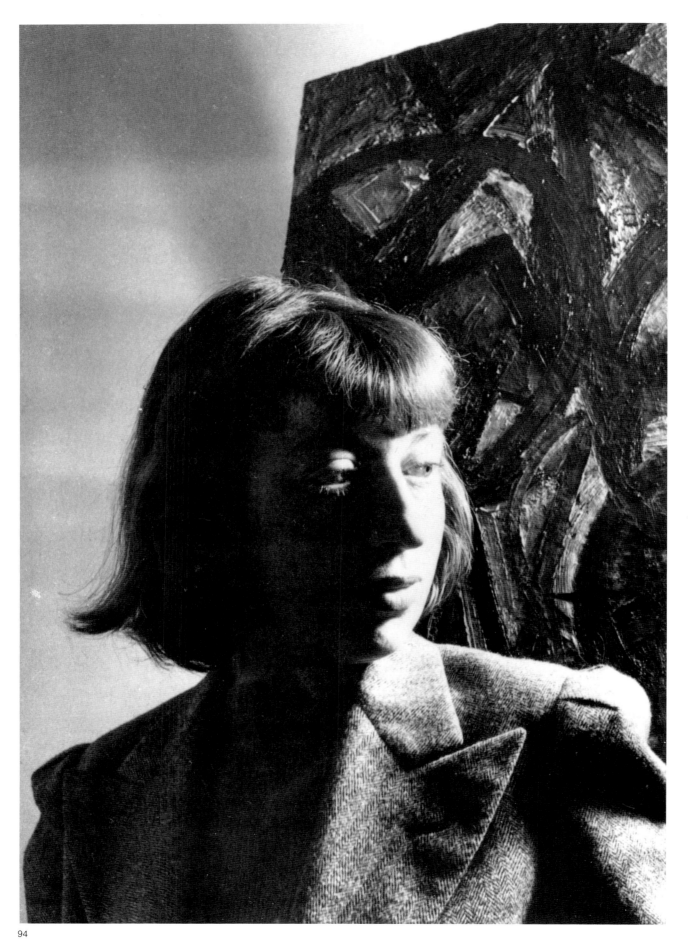

94

Chronology

1908 October 27—Lena Krassner born in Brooklyn, New York, to Joseph and Anna Krassner, recent Russian immigrants. She is the fourth of five children.

1922–25 Attends Women's Art School at Cooper Union, New York.

1928 Takes course at the Art Students League, New York.

1929 Graduates from Women's Art School at Cooper Union. Begins studies at National Academy of Design, New York; meets Ilya Bolotowsky, Giorgio Cavallon, and Igor Pantuhoff there. First encounters the art of Henri Matisse and Pablo Picasso, at the newly opened Museum of Modern Art, New York.

1932 Completes program at National Academy.

1933 Attends City College, where she studies education, and Greenwich House, where she works with Job Goodman, a follower of Thomas Hart Benton. Works as a cocktail waitress at Sam Johnson's nightclub in Greenwich Village. Meets poet and burgeoning critic Harold Rosenberg.

1934 January–March—employed on Public Works of Art Project.

1934–35 Works as an artist for the Temporary Emergency Relief Administration.

1935 August—with Rosenberg works in the Mural Division of the Works Progress Administration Federal Art Project (WPA/ FAP), as assistant to Max Spivak. Is influenced by Giorgio de Chirico's art. Meets Arshile Gorky and Willem de Kooning. With Igor Pantuhoff rents rooms in Rosenberg's apartment on West Fourteenth Street. About this time begins calling herself "Lee" rather than "Lenore" and drops the second s in her family name.

1936 Has first contact with Jackson Pollock, at an Artists Union loft party.

1937 Begins studies at the Hans Hofmann School of Fine Arts on West Ninth Street. Becomes friends with Lillian Olinsey (Kiesler), Mercedes Carles (Matter), and Ray Kaiser (Eames). Participates in her first group exhibition, at the ACA Gallery.

1938 As part of her WPA duties enlarges Leonard Jenkins's sketch for his *History of Navigation* into a mural for a Brooklyn library and paints a full-scale mural from a sketch by de Kooning.

1939 Attends meeting in Arshile Gorky's studio regarding status of vanguard art in the United States. Is deeply impressed by Picasso's *Guernica*.

1940 Becomes active in Artists Union; pickets with striking workers. Meets the young art critic Clement Greenberg at a party at the Rosenbergs' apartment and invites him to Hofmann's lectures. Becomes acquainted with Piet Mondrian through their membership in the American Abstract Artists group (AAA). Ends studies at Hofmann's school.

1941 November—John Graham invites her, along with Pollock, de Kooning, and David Burliuk, to participate in an exhibition of American and French painting at the McMillen Gallery, New York, to be held the following January. As a result of this invitation she meets Pollock for the second time; sees him constantly thereafter and is living with him in his Eighth Street apartment by the fall of 1942.

94. Lee Krasner, c. 1938
Photograph by Maurice Berezov

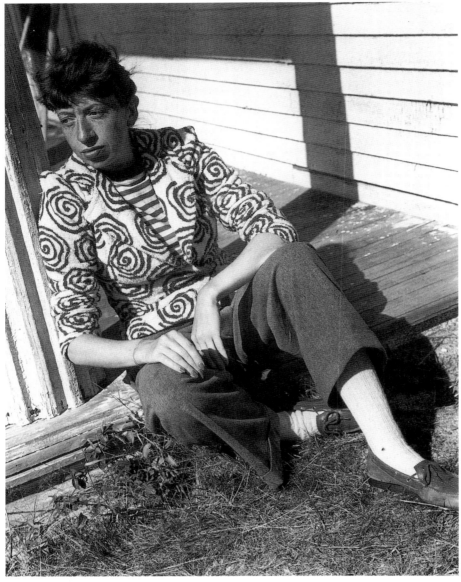

95

1942 Supervises exhibitions in War Services Office and oversees creation of large poster photo-collages advertising the war effort, for exhibition in department stores. Employs Pollock as part of the project. Introduces Pollock to Mercedes Carles and Herbert Matter; also to Hans Hofmann, who then visits his studio. Matter takes the critic James Johnson Sweeney to see Pollock's work, and Sweeney invites Peggy Guggenheim to Pollock's studio. (Guggenheim opens her gallery, Art of This Century, the same year.) Mondrian compliments Krasner's painting in the AAA annual, impressed by her "rhythm."

1943 Experiments in several styles; keeps overpainting until her works resemble uniform gray slabs. An exception is *Igor* (plate 29), which indicates the direction she will take in the late 1950s. Refuses Guggenheim's invitation to exhibit with women artists. Visits Hofmann's studio with Pollock and sees Hofmann's paintings for the first time.

1944 Persuades Guggenheim to show Hofmann's work. Uses Hofmann's classroom in Provincetown, Massachusetts, for studio. Sidney Janis reproduces her untitled abstraction in *Abstract and Surrealist Art in America*. She destroys most of her extant work.

1945 Spends two weeks at summer house of Barbara and Reuben Kadish in East Hampton, on Long Island, New York. Suggests to Pollock that they move to East Hampton for a year. She and Pollock find farmhouse, barn, and five acres in The Springs and persuade Guggenheim to loan them $2,000 for down payment. October 25—marries Pollock at Marble Collegiate Church, Fifth Avenue, New York; May Rosenberg is witness. November—she and Pollock move to The Springs.

1946 Helps renovate house and barn. Makes first Little Image paintings, in allover style.

95. Lee Krasner in front of Tillie Shahn's house, Truro, Massachusetts, 1944
Photograph by Bernard Schardt

96. *Messenger*, 1959
Oil on canvas, 69 x 69 in.
(175.3 x 175.3 cm)
John Eric Cheim, New York; Courtesy Robert Miller Gallery, New York

112

1947 Makes two mosaic tables (see plate 90), using Pollock's leftover WPA tesserae.

1948 Both she and Pollock sign letter protesting Emily Genauer's unfavorable review of Gorky's last show.

1949 Ends Little Image series.

1950 Summer—starts painting gestural abstraction, *Ochre Rhythm* (plate 41). Hans Namuth photographs her at work on series of "personage" paintings, which she later destroys. Both Krasner and Pollock exhibit in *Ten East Hampton Abstractionists*, Guild Hall, East Hampton.

1951 Continues gestural abstractions. Begins painting series of color-field abstractions, which were exhibited in her first solo show, held at Betty Parsons Gallery. Later she reworks all but two of these works for her 1955 exhibition of large collage paintings.

1953 Destroys series of black-and-white drawings and later this year uses the remnants to make her first important series of collages.

1954 Exhibits in her first group show of all women artists, Hampton Gallery and Workshop, Amagansett.

1955 Undergoes psychoanalysis with Dr. Leonard Siegel, a Sullivanian, because of marriage problems. Has a solo show of large collage paintings at the Stable Gallery, New York; Greenberg later terms this exhibition one of the best of the decade.

1956 Paints *Prophecy* (plate 54) in new figurative style. July 12—sails to Europe on first trip abroad. August 11—Pollock killed in automobile accident. August 12—Greenberg calls Krasner in Paris with the news. She returns immediately to arrange funeral. Stops working only briefly, then starts using Pollock's studio in the barn and begins cycle of seventeen large

97

paintings, completed in eighteen months, known as the Earth Green series, beginning with *Birth* (plate 55) and *Three in Two*.

1958 Based on the success of the Earth Green series, Greenberg offers Krasner an exhibition at French and Co., New York. Participates in her first group exhibition held abroad, the Osaka Art Festival, Osaka, Japan.

1959 Completes two monumental mosaic murals for the Uris Brothers at 2 Broadway, New York (plate 92). Begins Umber series, also known as the Night Journeys. Greenberg regards these works as reactionary; because of his negative response, Krasner cancels the exhibition with French and Co.

1963 Undergoes operation for an aneurysm and stops painting the Night Journeys. Breaks her right wrist and does small paintings in bright colors with left hand. Frank Lloyd of Marlborough asks her to join gallery; she refuses because he represents the Pollock estate.

1965 Enjoys the success of her first retrospective, which opens at Whitechapel Art Gallery, London. This is also the first solo exhibition of her work outside the United States.

1966 After seeing her show at Whitechapel Art Gallery, Lloyd again asks Krasner to join Marlborough Gallery; this time she accepts.

1972 April 17—pickets Museum of Modern Art with the group Women in the Arts because the museum does not show enough work by women artists.

1974 Receives Augustus St. Gaudens Medal, from the Cooper Union Alumni Association, and the Lowe Fellowship for Distinction, awarded by Barnard College.

1976 Joins Pace Gallery. Initiates new series of postmodern works, which incorporate her old Hofmannesque drawings.

1977 Receives honorary award from the Long Island Women Achievers in Business and the Professions.

1978 She is the only female artist represented in the exhibition *Abstract Expressionism: The Formative Years*, which was cosponsored by the Herbert F. Johnson Museum of Art at Cornell University and the Whitney Museum of American Art.

1980 Receives Outstanding Achievement in the Visual Arts award, from the Women's Caucus for Art, and is given an award for Distinguished Contributions to Higher Education, from the Stony Brook Foundation.

1981 Joins Robert Miller Gallery, New York, at the end of the year.

1982 Made a *chevalier* of the Ordre des Arts et des Lettres, awarded by the French Minister of Culture.

1983 Travels to the Museum of Fine Arts, Houston, for her first retrospective in the United States, curated by Barbara Rose.

1984 June 20—dies in New York.

97. Lee Krasner, December 1977
Photograph by Renate Ponsold Motherwell

Exhibitions

Solo Exhibitions

1951
Paintings 1951, Lee Krasner, Betty Parsons Gallery, New York, October 15–November 13.

1954
Lee Krasner, House of Books and Music, East Hampton, New York.

1955
Lee Krasner, Stable Gallery, New York.

1958
Lee Krasner: Recent Paintings, Martha Jackson Gallery, New York, February 28–March 22.

1959
Lee Krasner: Paintings, 1947–1959, Signa Gallery, East Hampton, New York, July 24–August 20.

1960
Exhibition of Recent Paintings by Lee Krasner, Howard Wise Gallery, New York, November 15–December 10.

1962
New Work by Lee Krasner, Howard Wise Gallery, New York, March 6–30.

1965
Lee Krasner: Paintings, Drawings and Collages, Whitechapel Art Gallery, London, September–October and tour throughout Britain organized by the Arts Council of Great Britain.
 Lee Krasner, Gouaches and Drawings, Franklin Siden Gallery, Detroit, November 8–27.

1967
Paintings by Lee Krasner, University Art Gallery, University of Alabama, Tuscaloosa.

1968
Lee Krasner: Recent Paintings, Marlborough-Gerson Gallery, New York, March.

1969
Lee Krasner: Recent Gouaches, Marlborough-Gerson Gallery, New York, September 27–October 18, and Reese Palley Gallery, San Francisco.

1973
Lee Krasner: Recent Paintings, Marlborough Gallery, New York.
 Lee Krasner: Large Paintings, Whitney Museum of American Art, New York, November 13, 1973–January 6, 1974.

1974
Lee Krasner: Selections from 1946–1972, Miami-Dade Community College, Miami, and tour to Beaver College, Glenside, Pennsylvania; Gibbes Art Gallery, Charleston, South Carolina.

1975
Lee Krasner: Collages and Works on Paper, 1933–1974, Corcoran Gallery of Art, Washington, D.C., January 11–February 16, and tour to Pennsylvania State University, State College; Rose Art Museum, Brandeis University, Waltham, Massachusetts.
 Works on Paper: 1937–1939, Marlborough Prints and Drawings Gallery, New York, October 11–November 1.

1977
Lee Krasner: Eleven Ways to Use the Words to See, Pace Gallery, New York, February 19–March 19.

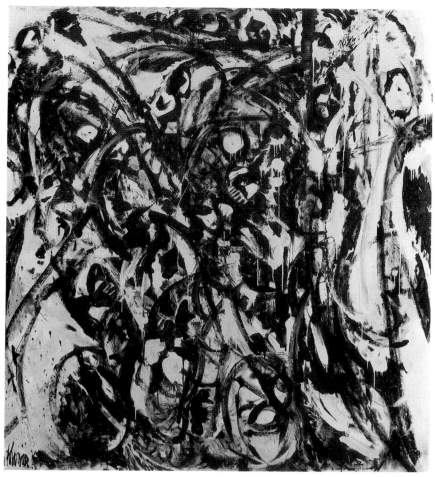

98

98. *Uncaged*, 1960.
Oil on cotton duck, 96⅞ x 93½ in. (246 x 237.4 cm)
Private collection, Paris; Courtesy Robert Miller
Gallery, New York

Lee Krasner: Paintings, Susanne Hilberry Gallery, Birmingham, Michigan.

1978
Lee Krasner: Works on Paper, 1938–77, Janie C. Lee Gallery, Houston, September 23–October 23.

1979
Lee Krasner: Paintings, 1959–1962, Pace Gallery, New York, February 3–March 10.

1980
Lee Krasner: Recent Works on Paper, Tower Gallery, Southampton, New York, August 16–29.

1981
Lee Krasner: Paintings, 1962 to 1971, Janie C. Lee Gallery, Houston, February 7–March 7.
Solstice, Pace Gallery, New York, March 20–April 18.
Lee Krasner: Paintings from the Late 1950s, Robert Miller Gallery, New York, October 26–November 20.

1983
Lee Krasner: A Retrospective, Museum of Fine Arts, Houston, October 27, 1983–January 8, 1984, and tour to the San Francisco Museum of Modern Art; Museum of Modern Art, New York; Centre Georges Pompidou, Paris.
Lee Krasner Retrospective, Supplement: The Education of an Artist, Museum of Fine Arts, Houston, and tour.

1984
Lee Krasner, Works on Paper, Brooklyn Museum, New York, December 20, 1984–February 25, 1985.

1985
Lee Krasner, Charcoal Drawings, 1938–1940, Robert Miller Gallery, New York, March 5–30.

1986
Lee Krasner Paintings from the Fifties, Betsy Rosenfield Gallery, Chicago, February 14–March 15.
Lee Krasner, Collages, Robert Miller Gallery, New York, October 7–November 1.

1987
Lee Krasner, Meredith Long Gallery, Houston.

1988
Lee Krasner: Paintings, 1956–1984, Fine Arts Center Art Gallery, State University of New York at Stony Brook, June 24–September 10.
Paintings from 1938–1943, Robert Miller Gallery, New York, September 8–October 1.

1989
Lee Krasner–Jackson Pollock, Kunstmuseum Bern, Bern, Switzerland, November 21, 1989–February 4, 1990.

1991
Lee Krasner Paintings, 1965–70, Robert Miller Gallery, New York, January 4–26.

1993
Lee Krasner: Umber Paintings, 1959–1962, Robert Miller Gallery, New York, January 1–30.

Selected Group Exhibitions

1937
Pink Slips over Culture, ACA Gallery, New York.

1940
American Abstract Artists Group, American Fine Arts Galleries, New York.
First Annual Exhibition of the American Modern Artists, Riverside Museum, New York.

1941
Fifth Annual Exhibition of the American Abstract Artists, Riverside Museum, New York. Also included in 1942, 1943.
Abstract Painting, organized by the WPA and circulated throughout the United States.

1942

American and French Paintings, McMillen Gallery, New York, January 20–February 6.

1944

Abstract and Surrealist Art in America, Mortimer Brandt Gallery, New York, November 29–December 30.

1945

A Problem for Critics, 67 Gallery, New York, May 14–July 7.

1948

The Modern Home Comes Alive: 1948–1949, Bertha Schaefer Gallery, New York.

1949

Man and Wife, Sidney Janis Gallery, New York.

1950

Ten East Hampton Abstractionists, Guild Hall, East Hampton, New York, July 1–20.

1953

Seventeen East Hampton Artists, Guild Hall, East Hampton, New York.

An Exhibition of Oils, Watercolors, Prints, and Sculpture by Eight Artists of Eastern Long Island, Hampton Gallery and Workshop, Amagansett, New York.

1954

Group Show—Eight Painters, Two Sculptors, Hampton Gallery and Workshop, Amagansett, New York.

1956

1956 Annual Exhibition: Sculpture, Paintings, Watercolors, and Drawings, Whitney Museum of American Art, New York. Also included in 1957.

1957

The Thirties: Painting in New York, Poindexter Gallery, New York.

1958

International Art of a New Era, Osaka Art Festival, Osaka, Japan.

Group Exhibition, Signa Gallery, East Hampton, New York.

1959

Arte nuova, Circolo degli Artisti, Palazzo Graneri, Turin, Italy.

1960

Opening Exhibition 1960, Signa Gallery, East Hampton, New York.

1961

Panorama, Galerie Beyeler, Basel, Switzerland.

Modern American Painting, Laing Art Gallery, Newcastle-upon-Tyne, England.

New York Scene, Marlborough Fine Arts, London.

Contemporary Paintings Selected from 1960–1961 New York Gallery Exhibitions, Yale University Art Gallery, New Haven, Connecticut.

1962

Group Show, Pennsylvania Academy of the Fine Arts, Philadelphia.

Women Artists in America Today, Mount Holyoke College, South Hadley, Massachusetts.

Continuity and Change: Forty-Five Abstract American Painters and Sculptors, Wadsworth Atheneum, Hartford, Connecticut, April 12–May 27.

1963

Hans Hofmann and His Students, International House, Denver, May 6–27, and Museum of Modern Art tour.

1964

Festival of the Arts Exhibition, Guild Hall, East Hampton, New York.

American Drawings, Solomon R. Guggenheim Museum, New York, September 17–October 22, and tour.

1965

Drawing Society: New York Regional Exhibition, Gallery of Modern Art, New York.

1966

1966 Invitational Exhibition, Parrish Art Museum, Southampton, New York.

1967

Large American Paintings, Jewish Museum, New York.

White House Rotating Exhibition, organized by the Smithsonian Institution, Washington, D.C.

1968

163rd Annual Exhibition, Pennsylvania Academy of the Fine Arts, Philadelphia.

Holland Festival: Critici Kiezen Grafiek, Haags Gemeentemuseum, The Hague, Netherlands.

First Annual Exhibition of the Artists of The Springs, Ashawagh Hall, The Springs, New York. (Krasner exhibited annually in the *Exhibitions of the Artists of The Springs* from 1968 until her death.)

Betty Parsons' Private Collection, Finch College Museum of Art, New York, and tour.

1969

Contemporary American Painting and Sculpture 1969, Krannert Art Museum, University of Illinois, Champaign, and tour.

Espaces abstraits de l'intuition à la formalisation, Galleria d'Arte Dortina, Milan.

1970

Contemporary Women Artists, Hathorn Gallery, Skidmore College, Saratoga Springs, New York, and tour.

Free Form Abstraction, Whitney Museum of American Art, New York.

American Action Painting, Marlborough Galleria d'Arte, Rome, April 11–May 9.

Unmanly Art, Suffolk Museum, Stony Brook, New York.

1973

Labyrinths: Women and the Arts: Multi Media, London.

1973 Biennial Exhibition of Contemporary American Art, Whitney Museum of American Art, New York.

1974

American Self-Portraits, National Portrait Gallery, Smithsonian Institution, Washington, D.C., and tour.

In den unzähligen Bildern de Lebens . . . Surrealität-Bildrealität 1924–1974, Städtische Kunsthalle, Düsseldorf, December 8, 1974–February 2, 1975, and tour.

1975

Subjects of the Artist: New York Painting, 1941–1947, Downtown Branch, Whitney Museum of American Art, New York, April 22–June 11.

Formative Years: Early Work by Prominent New York Artists, Visual Arts Museum, New York.

1976

Forty Years of American Collage, Buecker and Harpsichords, New York and tour.

American Artists '76: A Celebration, Marion Koogler McNay Art Institute, San Antonio, Texas.

Women Artists: 1550–1950, Los Angeles County Museum of Art, December 21, 1976–March 13, 1977, and tour.

1977

Provincetown Painters, 1890s–1970s, Everson Museum of Art, Syracuse, New York, April 1–June 6, and tour.

Contemporary Issues: Work on Paper by Women, Woman's Building, Los Angeles, and tour.

1978

Abstract Expressionism: The Formative Years, Herbert F. Johnson Museum, Cornell University, Ithaca, New York, March 30–May 14, and tour.

American Painting of the 1970s, Albright-Knox Art Gallery, Buffalo, and tour.

1979

Hans Hofmann as Teacher: Drawings by His Students, Metropolitan Museum of Art, New York, January 23–March 4.

Art in America after WWII, Solomon R. Guggenheim Museum, New York.

Around Jackson Pollock, East Hampton, the 1950s, Centre Culturel Américain, Paris. Circulated in the U.S the following year as *Seventeen Abstract Artists of East Hampton: The Pollock Years, 1946–56*.

1980

Pioneering Women Artists, 1900–1940, La Boetie, New York.

Painting and Sculpture by Candidates for Art Awards, American Academy and Institute of Arts and Letters, New York.

The Fifties: Aspects of Painting in New York, Hirshhorn Museum and Sculpture Garden, Smithsonian Institution, Washington, D.C., May 22–September 21.

1981

Abstract Expressionists and Their Precursors, Nassau County Museum of Fine Arts, Roslyn, New York.

Tracking the Marvelous, Grey Art Gallery and Study Center, New York University, New York, April 28–May 30.

Krasner-Pollock: A Working Relationship, Guild Hall Museum, East Hampton, New York, August 8–October 4, and tour.

1982

Carnegie International 1982, Museum of Art, Carnegie Institute, Pittsburgh, and tour.

1984

American Women Artists (Part 1: 20th-Century Pioneers), Sidney Janis Gallery, New York, January 12–February 4.

Reflections of Nature: Flowers in American Art, Whitney Museum of American Art, New York, March 1–May 20.

Un Art autre/Un Autre Art, Artcurial, Centre d'Art Plastique Contemporain, Paris.

1985

Flying Tigers: Paintings and Sculpture in New York, 1936–46, Bell Gallery, Brown University, Providence, Rhode Island, April 27–May 27, and tour.

1986

Arte e scienza/Arte e alchimia, Venice Biennale.

Individuals: A Selected History of Contemporary Art, 1945–1986, Museum of Contemporary Art, Los Angeles, December 10, 1986–January 10, 1988.

1987

After Matisse, Phillips Collection, Washington, D.C.

Abstract Expressionism: The Critical Developments, Albright-Knox Art Gallery, Buffalo.

Drawing in the East End, 1940–1988, Parrish Art Museum, Southampton, New York, September 18–November 13.

Just Like a Woman, Greenville County Museum of Art, Greenville, South Carolina.

Vital Signs, Whitney Museum of American Art, New York.

Contemporary American Collage, 1960–1986, Herter Art Gallery, University of Massachusetts, Amherst, November 9–December 11, and tour.

1989

East Hampton Avant-Garde: A Salute to the Signa Gallery, 1957–60, Guild Hall Museum, East Hampton, New York, August 12–September 23.

Positions of Art in the Twentieth Century: Fifty Women Artists, Museum Wiesbaden, West Germany, September 9–November 11.

The Gestural Impulse, 1945–1960, Whitney Museum of American Art, Downtown at Federal Reserve Plaza, New York, September 29–December 1.

Abstract Expressionism—Other Dimensions, Janice Voorhees Zimmerli Art Museum, New Brunswick, New Jersey, October 26–December 3, and tour.

1990

Kunstlerinnen des 20. Jahrhunderts, Museum Wiesbaden, Wiesbaden, Germany.

1991

Recent Acquisitions and Loaned Works, National Museum of Women in the Arts, Washington, D.C., February 3–April 28.

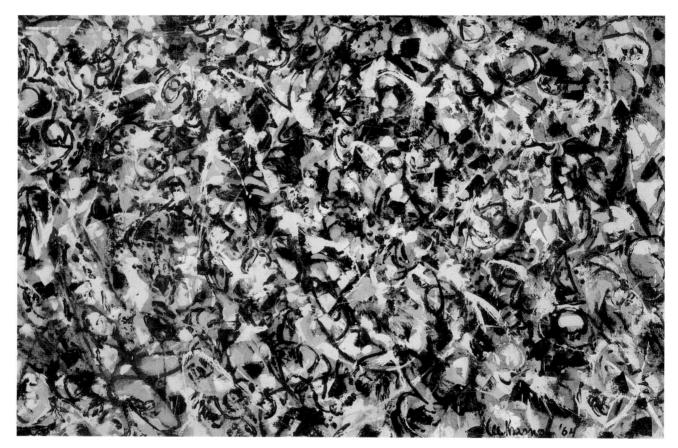

99. *The Springs,* 1964
Oil on canvas, 43 x 66 in. (109.2 x 167.6 cm)
National Museum of Women in the Arts,
Washington, D.C.; Gift of Wallace and
Wilhelmina Holladay

Public Collections

Aachen, Germany, Ludwig Collection
Brooklyn, New York, Brooklyn Museum
Buffalo, New York, Albright-Knox Art
Gallery
Canberra, Australia, Australian National
Gallery
Castagnola, Switzerland, Thyssen-Bornemisza
Collection
Cologne, Germany, Museum Ludwig
Dallas, Texas, Dallas Museum of Art
East Hampton, New York, Guild Hall
Museum
Flint, Michigan, Flint Institute of Arts
Greensboro, North Carolina, University of
North Carolina, Weatherspoon Art Gallery
Houston, Texas, Museum of Fine Arts
Indianapolis, Indiana, Indianapolis Museum
of Art
London, England, Tate Gallery
Los Angeles, California, Atlantic Richfield
Corporation Art Collection
Melbourne, Australia, National Gallery of
Victoria
Mexico City, Mexico, Centro Cultural de
Arte Contemporaneo
New Haven, Connecticut, Yale University Art
Gallery

New York, New York, Deutsche Bank, AG
New York, New York, Metropolitan
Museum of Art
New York, New York, Museum of Modern
Art
New York, New York, Paine Webber Group,
Inc.
New York, New York, Solomon R. Guggen-
heim Museum
New York, New York, Whitney Museum of
American Art
Philadelphia, Pennsylvania, Philadelphia
Museum of Art
Purchase, New York, Neuberger Museum,
State University of New York
Tuscaloosa, Alabama, Moody Gallery of Art,
University of Alabama
Venice, Italy, Peggy Guggenheim Collection
Washington, D.C., Hirshhorn Museum and
Sculpture Garden, Smithsonian Institution
Washington, D.C., National Gallery of Art
Washington, D.C., National Museum of
American Art, Smithsonian Institution
Washington, D.C., National Museum of
Women in the Arts

Selected Bibliography

Interviews and Statements

Bourdon, David. "Lee Krasner: 'I'm Embracing the Past,'" *Village Voice*, March 7, 1977, p. 57.

Cannell, Michael. "An Interview with Lee Krasner," *Arts Magazine* 59 (September 1984): 87–89.

Cavaliere, Barbara. "An Interview with Lee Krasner." *Flash Art*, nos. 94–95 (January–February 1980): 14–16.

Foster, Sherril. "Profile: An Interview with Lee Krasner."*Hamptons Scene*, August 2, 1980, p. 9.

Glaser, Bruce. "Jackson Pollock: An Interview with Lee Krasner."*Arts Magazine* 41 (April 1966): 36–39.

Krasner, Lee. Interviews with Dorothy Seckler, November 2, 1964; December 14, 1967; and April 11, 1968. Archives of American Art, Smithsonian Institution, Washington, D.C.

————. Statement in Charlotte Willard, "Eye to I." *Art in America* 54 (March–April 1966): 55.

————. Interview with Barbara Rose, July 1966. Archives of American Art, Smithsonian Institution, Washington, D.C.

————. Interview with Dolores Holmes, 1972. Archives of American Art, Smithsonian Institution, Washington, D.C.

————. "She Has Been There Once or Twice." Interview with Gaby Rodgers, 1977. Archives of American Art, Smithsonian Institution, Washington, D.C.

————. Statement in *The Provocative Years, 1935–1945: The Hans Hofmann School and Its Students in Provincetown*, p. 16. Provincetown, Mass.: Provincetown Art Association and Museum, 1990.

Myers, John Bernard. "Naming Pictures: Conversations between Lee Krasner and John Bernard Myers." *Artforum* 23 (November 1984): 69–73.

Nemser, Cindy. "A Conversation with Lee Krasner." *Arts Magazine* 47 (April 1973): 43–48.

Plessix, Francine du, and Cleve Gray. "Who Was Jackson Pollock?" *Art in America* 55 (May–June 1967): 48–59.

Rago, Louise. "We Interview Lee Krasner." *School Arts* 60 (September 1960): 31–32.

Monographs and Solo-Exhibition Catalogs

Appelhof, Ruth Ann. "Lee Krasner: The Swing of the Pendulum." M.A. thesis, Syracuse University, 1975.

Baro, Gene. *Lee Krasner: Collages and Works on Paper, 1933–1974.* Washington, D.C.: Corcoran Gallery of Art, 1975.

Cheim, John, et al. *Lee Krasner: Paintings from 1965 to 1970.* New York: Robert Miller Gallery, 1991.

Howard, Richard. *Lee Krasner: Paintings, 1959–1962.* New York: Pace Gallery, 1979.

Landau, Ellen G. "Lee Krasner: A Study of Her Early Career (1926–1949)." Ph.D. diss., University of Delaware, 1981.

Lee Krasner. New York: Marlborough-Gerson Gallery, 1968.

Lee Krasner. New York: Marlborough-Gerson Gallery, 1969.

Lee Krasner. Miami: Miami-Dade Community College and Beaver College, 1974.

Lee Krasner: Paintings from the Late Fifties. New York: Robert Miller Gallery, 1982.

Lee Krasner: Recent Paintings. New York: Marlborough Gallery, 1973.

Novak, Barbara. *Lee Krasner: Recent Work.* New York: Pace Gallery, 1981.

Ossorio, Alfonso. *Exhibition of Recent Paintings by Lee Krasner.* New York: Howard Wise Gallery, 1960.

Paintings by Lee Krasner. Tuscaloosa: University of Alabama Art Gallery, 1967.

Robertson, Bryan, and B. H. Friedman. *Lee Krasner: Paintings, Drawings and Collages.* London: Whitechapel Art Gallery, 1965.

——— and Robert Hughes. *Lee Krasner Collages.* New York: Robert Miller Gallery, 1986.

Rose, Barbara. *Lee Krasner: A Retrospective.* Houston: Museum of Fine Arts; New York: Museum of Modern Art, 1983.

Tucker, Marcia. *Lee Krasner: Large Paintings.* New York: Whitney Museum of American Art, 1974.

Periodicals, Books, and Group-Exhibition Catalogs

"The Abstract Art of Lee Krasner." *Times* (London), September 22, 1965.

The Americans: The Collage. Houston: Contemporary Arts Museum, 1982.

Ashton, Dore. "Fifty-seventh Street in Review." *Art Digest* 26 (November 1951): 59–60.

———. *The New York School.* New York: Viking Press, 1973.

Baer-Bogenschutz, Dorothee. "Krasner/Pollock." *Contemporanea* 3 (April 1990): 92.

Baker, A. T. "Out of the Shade." *Time,* November 19, 1973, pp. 76–77.

Ballo, Guido, Pietro Marion, and Franco Russoli. *Aspetti dell'informale.* Milan: Palazzo Reale, 1971.

Baro, Gene. *Twelve American Masters of Collage.* New York: Andrew Crispo Gallery, 1977.

———. *Carnegie International.* Pittsburgh: Carnegie Institute, 1982.

Bell, Tiffany, Dore Ashton, and Irving Sandler. *After Matisse.* New York: Independent Curators, 1986.

Berkson, Bill. *In Memory of My Feelings.* New York: Museum of Modern Art, 1967.

Blum, June. *Unmanly Art.* Stony Brook, N.Y.: Suffolk Museum, 1973.

Brach, Paul. "Tandem Paint: Krasner/Pollock." *Art in America* 70 (March 1982): 92–95.

Brenson, Michael. "Lee Krasner Pollock Is Dead; Painter of New York School." *New York Times,* June 21, 1984, p. D23.

Busa, Christopher. "The Legacy of Lee Krasner: The Pollock-Krasner Foundation." *Provincetown Arts* 5 (1989): 140–43.

Campbell, Lawrence. "Of Lilith and Lettuce." *Artnews* 67 (March 1968): 42–43, 61–64.

Cathcart, Linda L. *American Painting of the 1970s.* Buffalo: Albright-Knox Art Gallery, 1978.

Cavaliere, Barbara. "Lee Krasner: A Meeting of Past and Present." *Soho Weekly News,* February 1, 1979, pp. 41, 44.

Friedman, B. H. "Manhattan Mosaic." *Craft Horizons* 19 (January–February 1959): 26–29.

Glueck, Grace. "Art Notes: . . . and Mr. Kenneth Does Her Hair." *New York Times,* March 17, 1968, sec. 2, p. 34.

———. "Art People: How to Recycle Your Drawings." *New York Times,* February 25, 1977, p. C18.

———. "Scenes from a Marriage: Krasner and Pollock." *Artnews* 80 (December 1981): 57–61.

Goodnough, Robert. "Reviews and Previews." *Artnews* 50 (November 1951): 53.

Gruen, John. *The Party's Over Now.* New York: Viking Press, 1967.

Harrison, Helen A. "Krasner-Pollock Show Traces a Partnership." *New York Times,* September 6, 1981.

Heartney, Eleanor. "New Foundation to Help Artists." *Artnews* 85 (January 1986): 156.

Hobbs, Robert, and Gail Levin. *Abstract Expressionism: The Formative Years.* Ithaca, N.Y.: Herbert F. Johnson Museum of Art, Cornell University; New York: Whitney Museum of American Art, 1978.

Hughes, Robert. "Lee Krasner." Typescript of lecture given at Guild Hall, East Hampton, New York, July 31, 1988, Robert Miller Gallery archives, New York.

Hunter, Sam. *Modern American Painting and Sculpture.* New York: Dell Publishing Co., 1959.

Hutchinson, Bill. "Overshadowed by Late Husband, Lee Krasner's an Artist, Too." *Miami Herald,* March 13, 1974, pp. C1–4.

Janis, Harriet, and Rudi Blesh. *Collage: Personalities—Concepts—Techniques.* Philadelphia: Chilton Book Company, 1962.

Kernan, Michael. "Her Life and Art Seen Whole at Last." *Washington Post,* October 23, 1983, pp. L1–2.

Kohlmeyer, Ida. *American Women: Twentieth Century.* Peoria, Ill.: Lakeview Center for the Arts, 1972.

Kozloff, Max, Dore Ashton, and Constance Schwartz. *The Abstract Expressionists and*

Their Precursors. Roslyn, N.Y.: Nassau County Museum of Fine Art, 1981.

Kramer, Hilton. "Lee Krasner's Art—Harvest of Rhythms." *New York Times,* November 22, 1973, p. C50.

———. "Art: Elegiac Works of Lee Krasner." *New York Times,* February 9, 1979, p. C25.

———. "Social Art and the Pollock/Krasner Connection." *New York Times,* November 15, 1981, pp. D37–38.

Kuthy, Sandor, and Ellen G. Landau. *Lee Krasner–Jackson Pollock.* Bern, Switzerland: Kunstmuseum and Musée des Beaux-Arts de Berne, 1989–90.

Landau, Ellen G. "Aspects of the Fifties." *Art Journal* 40 (Fall–Winter 1980): 387–89.

———. "Lee Krasner's Early Career, Part One: 'Pushing in Different Directions.'" *Arts Magazine* 56 (October 1981): 110–22.

———. "Lee Krasner's Early Career, Part Two: The 1940s." *Arts Magazine* 56 (November 1981): 80–89.

———. "Lee Krasner's Past Continuous." *Artnews* 83 (February 1984): 68–76.

Larson, Kay. "Lee Krasner's Enduring Gestures." *New York,* January 14, 1985, pp. 48–49.

"Lee Krasner." *Times* (London), June 22, 1984, p. 14.

Levin, Kim. "Art: Lee Krasner: Paintings from the Late Fifties." *Village Voice,* November 16, 1982, p. 72.

Linker, Kate. "Krasner/Pollock: A Working Relationship (Grey Art Gallery)." *Artforum* 20 (February 1982): 86–87.

Lurie, Sheldon M. *In Celebration of Age: Twentieth-Century Artists in Their Seventies and Eighties.* Miami: Frances Wolfson Art Gallery, 1982.

Lynton, Norbert. "Obstacle Race." *Guardian* (London and Manchester, England), September 27, 1965, p. 7.

———. "London Letter." *Art International* 9 (November 1965): 32–33.

Mollison, James, and Laura Murray, eds. *Australian National Gallery: An Introduction.* Canberra: Australian National Gallery, 1982.

Munro, Eleanor. "Krasner in the Sixties, Free for the Big Gesture." *Art/World,* February 16, 1979, pp. 1–6.

———. *Originals: American Women Artists.* New York: Simon and Schuster, 1979.

Myers, John Bernard. *Tracking the Marvelous: A Life in the New York Art World.* New York: Random House, 1981.

Naifeh, Steven, and Gregory White Smith. *Jackson Pollock: An American Saga.* New York: Clarkson N. Potter, 1989.

Namuth, Hans. *Fifty-two Artists: Photographs by Hans Namuth*, ed. Allan Schoener. Scarsdale, N.Y.: Committee for the Visual Arts, 1973.

Nemser, Cindy. "Lee Krasner's Paintings, 1946–49." *Artforum* 12 (December 1973): 61–65.

———. "The Indomitable Lee Krasner." *Feminist Art Journal* 4 (Spring 1975): 9.

O'Doherty, Brian. "Review." *New York Times*, March 14, 1962, p. 79.

Polcari, Stephen. "In the Shadow of an Innovator." *Art International* 12 (August 1990): 105–7.

Porter, Fairfield. "Reviews and Previews." *Artnews* 54 (November 1955): 66–67.

———. "Reviews and Previews." *Artnews Annual* 26 (1957): 170.

Potter, Jeffrey, ed. *To a Violent Grave: An Oral Biography of Jackson Pollock*. Wainscott, N.Y.: Pushcart Press, 1987.

Preston, Stuart. "Ten East Hampton Abstract Artists." *New York Times*, July 16, 1950, sec. 2, p. 2.

———. "Among One Man Shows." *New York Times*, October 21, 1951, sec. 2, p. 9.

———. "Modern Work in Diverse Shows." *New York Times*, October 2, 1955, sec. 2, p. 15.

———. "Art Review." *New York Times*, November 19, 1960, p. 43.

Ratcliff, Carter. "New York Letter." *Art International* 13 (Christmas 1969): 74.

Robertson, Bryan. "The Nature of Lee Krasner." *Art in America* 61 (November–December 1973): 83–87.

Rose, Barbara. "American Great: Lee Krasner." *Vogue* 159 (June 1972): 118–21, 154.

———. "Lee Krasner and the Origins of Abstract Expressionism." *Arts Magazine* 51 (February 1977): 96–100.

———. *Krasner/Pollock: A Working Relationship*. New York: Grey Art Gallery and Study Center, New York University, 1981.

———. "Life on the Project: Lee Krasner, Jackson Pollock and the Federal Art Projects of the Works Progress Administration." *Partisan Review* 52 (November 2, 1985): 74ff.

Rosenberg, Harold. "The American Action Painters." *Artnews* 51 (December 1952): 22–23, 48–50.

———. "The Art Establishment." *Esquire* 62 (January 1965): 43–46, 114.

———. "The Art World." *New Yorker*, August 26, 1967, pp. 90, 93–97.

Rubinstein, Charlotte Streifer. *American Women Artists*. New York: Avon Books, 1982.

Russell, John. "It's Not 'Women's Art,' It's Good Art." *New York Times*, July 24, 1983, pp. B1, B25.

Siegel, Jeanne. *Collage Expanded*. New York: Visual Arts Museum, 1984.

Solomon, Deborah. *Jackson Pollock: A Biography*. New York: Simon and Schuster, 1987.

Southgate, Patsy. "The Eastern Long Island Painters." *Paris Review*, no. 21 (Spring–Summer 1959): 104–21.

Springs, Harry. "Her Infinite Variety." *In Contemporary Women Artists*. Saratoga Springs, N.Y.: Hathorn Gallery, Skidmore College, 1970.

Stevens, Mark. "The American Masters." *Newsweek*, January 2, 1984, pp. 66–68.

Taylor, Robert. "Lee Krasner Claims Her Place in Art." *Boston Evening Globe*, September 21, 1975, pp. A9, A12.

Twenty-five: Namuth and Twenty-four Artists. Frederick, Md.: University Publications of America, 1982.

Van Devanter, Ann C., and Alfred V. Frankenstein. *American Self-Portraits, 1970–1973*. Washington, D.C.: National Portrait Gallery, Smithsonian Institution, 1974.

Vetrocq, Marcia E. "An Independent Tack: Lee Krasner." *Art in America* 72 (May 1984): 136ff.

Wagner, Anne M. "Lee Krasner as L.K." *Representations* 25 (Winter 1989): 42–57.

Wallach, Amei. "Lee Krasner, Angry Artist." *Newsday*, November 12, 1973, pp. A4, A13.

———. "Lee Krasner: Out of Jackson Pollock's Shadow." *Newsday's Magazine for Long Island*, August 23, 1981, pp. 10–15, 29–31, 33–34.

Wasserman, Emily. "Lee Krasner in Mid-Career." *Artforum* 6 (March 1968): 38–43.

100

100. *Mysteries*, 1972
Oil on cotton duck, 69½ x 89½ in.
(176.5 x 227.4 cm)
The Brooklyn Museum;
Dick S. Ramsay Fund

INDEX

Photography Credits

The photographers and the sources of photographic material other than those indicated in the captions are as follows: